WORLD
FILM
LOCATIONS
LIVERPOOL

Edited by Jez Conolly and Caroline Whelan

First Published in the UK in 2013 by
Intellect Books, The Mill, Parnall Road,
Fishponds, Bristol, BS16 3JG, UK

First Published in the USA in 2013
by Intellect Books, The University of
Chicago Press, 1427 E. 60th Street,
Chicago, IL 60637, USA

Copyright ©2013 Intellect Ltd

Cover photo: *Nowhere Boy* (2010)
Ecosse Films/ Film4/ UK Film Council

Copy Editor: Emma Rhys

Design support: Jo Amner

A Catalogue record for this book is
available from the British Library

World Film Locations Series
ISSN: 2045-9009
eISSN: 2045-9017

World Film Locations Liverpool
ISBN: 978-1-78320-026-9
ePub ISBN: 978-1-78320-110-5
ePDF ISBN: 978-1-78320-109-9

Printed and bound by
Bell & Bain Limited, Glasgow

WORLD
FILM
LOCATIONS
LIVERPOOL

EDITORS
Jez Conolly and Caroline Whelan

SERIES EDITOR & DESIGN
Gabriel Solomons

CONTRIBUTORS
Nicola Balkind
David Owain Bates
Marcelline Block
Marco Bohr
Paul Cartwright
Helen Cox
Wendy Everett
Julia Hallam
Scott Jordan Harris
Susan James
Linda Jones
Tim Kelly
John Maguire
Jacqui Miller
Neil Mitchell
Esperanza Miyake
Dióg O'Connell
Rebekka O'Grady
David Parkinson
Nick Riddle
Les Roberts
Roger Shannon

LOCATION PHOTOGRAPHY
Paul Cartwright
(unless otherwise credited)

LOCATION MAPS
Joel Keightley

PUBLISHED BY
Intellect
The Mill, Parnall Road,
Fishponds, Bristol, BS16 3JG, UK
T: +44 (0) 117 9589910
F: +44 (0) 117 9589911
E: *info@intellectbooks.com*

CONTENTS

ACKNOWLEDGEMENTS

We would to thank series editor Gabriel
Solomons for all of his help and guidance in
preparing this book. We also acknowledge
and greatly appreciate the work of all of our
contributors, who collectively have brought a
warm enthusiasm and a good deal of knowledge
to the project. Special thanks go to Lynn Saunders
at the Liverpool Film Office.

JEZ CONOLLY AND CAROLINE WHELAN

INTRODUCTION

World Film Locations Liverpool

I had a dream. I found myself in a dirty, sooty city. It was night and winter; and dark and raining. I was in Liverpool. In the centre was a round pool; in the middle of it a small island. On it stood a single tree; a magnolia in a shower of reddish blossoms. It was as though the tree stood in the sunlight, and were, at the same time, the source of light. Everything was extremely unpleasant; black and opaque – just as I felt then. But I had a vision of unearthly beauty […] and that's why I was able to live at all. Liverpool is the pool of life.
CARL GUSTAV JUNG

'LIVERPOOL': JUST THE WORD ITSELF is a key into a special part of British culture. At least as much as London, it is a name when heard or read that instantly takes people from around the world to an easily imagined place; from the cavern to the cathedrals, from the ferry to the football grounds, from the world-famous waterfront to the Walker Art Gallery (the latter coupling provides the locations for the first and last scene reviews in this book), it's somewhere so vivid in our minds that we can close our eyes and see it even if we've never been there.

This notional 'film' of Liverpool that so many of us play on a loop in our heads is naturally one that is inked in with the colours of its incomparable soundtrack; the music makes the pictures, the pictures get cut out and made into a flick book, the flick book gets thumbed through and the city dances into life with all the hectic, stroboscopic passion of a Beatles gig observed via zoetrope.

Some of the earliest makers of moving images stopped off at Liverpool on their travels; they came, the likes of Lumière, Mitchell and Kenyon, Friese-Greene, their cameras turned over and captured motion, their volatile spools of nitrate stock survived in canisters, invaluable time capsules allowing us a look back at the river, the docks, the streets, the people. Those people have now gone, so have swathes of the city that can be glimpsed in those early films, thanks in no small part to German bombs, to slum clearance, to town planners. But Liverpool has endured, sometimes by the skin of its teeth, and the fragments of film pressed between the covers of this book are something of a testament to that survival instinct.

Other than the capital, Liverpool has attracted more film-makers to its locations than any other British city, sometimes doubling for London, New York, Chicago, Paris, Rome, Moscow, sometimes playing itself, sometimes playing a version of its own past life for the benefit of one more Beatles biopic. The screen Liverpool, the Liverpool of the mind's eye that this book reflects, is always a place of passion, humour, pride, warmth. In the words of John Lennon: 'There's a place / Where I can go, / When I feel low, / When I feel blue. / And it's my mind, / And there's no time when I'm alone'. ✠

Jez Conolly and Caroline Whelan, Editors

LIVERPOOL

City of the Imagination

Text by
JULIA
HALLAM

If Liverpool didn't exist,
it would have to be invented.
Félicien De Myrbach, quoted in
Of Time and the City (TERENCE DAVIES, 2008)

A city on the edge, a city more Celtic than English, a city of intense passion, of humour, music, poets and football clubs, a city disliked by Tory politicians and their ilk for its 'bolshy' attitude to authority and subversive determination to do things its own way. Liverpool has always figured as a place of danger in the English imagination: the epicentre of free trade and 'gateway to Empire' in the nineteenth century, the great wealth generated by the international slave trade also became a source of notoriety. Philanthropic gesture bequeathed the city some of the finest civic buildings in Europe, including the magnificent St George's Hall, while astute commercial acumen commissioned Jesse Hartley to build the world's first secure warehouse system – the Albert dock – completed in 1846. By the beginning of the twentieth century, Liverpool's docks were some of the largest in Europe; the city

was home to more than 700,000 people, many of them seafarers and Irish émigrés living in the densely crowded courts bordering the waterfront.

When the Lumière Brothers' cameraman Jean Alexandre Louis Promio stepped off the train at Lime Street en route to Ireland in 1897, he set up his camera on St Georges Plateau and recorded the first moving images of the city in front of the huge neoclassical hall. At this time St Georges Hall defined the city's identity internationally, just as the Liver Birds atop the Royal Liver Building and the 'Three Graces' skyline form the iconic epicentre of the city's public image today. Early film-makers were captivated by the busy waterfront, capturing scenes of loading and passenger embarkation in films such as Cunard Mail Steamer *Lucania Leaving for America* (Mitchell and Kenyon, 1901). A thrilling chase sequence on the Overhead Railway and across rooftops of the embarkation sheds at the end of *The Clouded Yellow* (1950) captures the view from the railway before it was demolished in 1956.

Stories of crime, hardship and immorality set in bleak nineteenth-century tenements and grim terraced streets typify Liverpool's early film history. Mitchell and Kenyon's *Arrest of Goudie* (1901), claimed as one of first dramatic stagings of a real crime for the screen, is set in the terraced streets of dockland Bootle, and *The Eviction* (1901) is set in worker's housing in Garston. *Her Benny* (1920), a classic 'rags to riches' tale, takes place amidst the crowded courts of Scotland Road, home to Liverpool's vibrant Irish population. British film in the post-war period continues these traditions; *Waterfront* (1950), a story of a mother abandoned by her sailor husband, is a typical British social-problem film set in the now demolished Gerard Gardens. Built in the 1930s to provide modern facilities and a clean environment, in *Waterfront* and the well-known *Violent Playground* (1958) the tenements are depicted as breeding grounds of criminality and immorality, their occupants

irrevocably tarnished by generations of seafaring and casual employment.

By the 1980s, Liverpool had become one of the poorest cities in Europe. The haunting beauty of its derelict dockyards and once grand civic buildings began to attract film-makers. Local writer Alan Bleasdale's poignant series of films for British television, *Boys from the Blackstuff* (1981), depicts the deserted Albert docks in a sequence where former docker and political activist George, wheelchair bound, reminisces about the hopes of his youth. George epitomizes the kind of heroes found in Ken Loach's controversial drama of dockland politics *The Big Flame* (1969), an ongoing concern in films such as *Dockers* (1999). The boost to local production from Channel 4 created a space for regional film-makers; *Letter to Brehznev* (1985) opens with the iconic waterfront seen by Russian sailors from an inward-bound ship heralding a romantic tale between seaman Peter and local girl Elaine who opts for life in Soviet Russia rather than staying in Thatcher's Britain. Yet it is perhaps Terence Davies's films of growing up in Liverpool in the 1950s that established Liverpool's landscapes and stories in the pantheon of British cinema; his painful reveries of remembrance and loss in *Distant Voices, Still Lives* (1988) and *The Long Day Closes* (1992) changed the grey terraced streets of childhood into palimpsests of longing and desire. *Of Time and the City* (2008) is an elegy to a city and a culture that in Davies's mind has all but disappeared, its landscapes re-packaged by the heritage industry, its people consumed by greedy materialism and footballers' 'wag' culture.

Since the 1980s the historic waterfront (declared a UNESCO world heritage site in 2004), and the rapidly re-developing wastelands around it, attracts film-makers worldwide; contemporary Liverpool has one of the most filmed landscapes in the United Kingdom, but it rarely plays itself. Apart from a handful of well-known films such as *Liam* (2000), *The 51st State* (2001) and *Nowhere Boy* (2009), the Victorian warehouses, Georgian terraces and neoclassical monuments are stand-ins for elsewhere. *Chariots of Fire* (1981) began the trend, using Liverpool's magnificent eighteenth-century town hall interior to represent the British embassy in Paris; the grand buildings nearby become Moscow in *The Hunt for Red October* (1989). In 1989 the city became the first in Britain to open a film office, a one-stop shop that takes care of all the needs of companies shooting in the city. Since 2008, the city has re-invented itself as a European Capital of Culture, attracting artists, musicians and film-makers to a city which in the words of one its well-known writers 'just loves to talk'. It's this ability to tell stories that helped to establish the city as the 'Hollywood of North'; more feature films were shot in Liverpool than in any other UK city outside London during the 1990s, a trend that seems set to continue with major productions such as *Sherlock Holmes* (2009), *Harry Potter and the Deathly Hallows Part 3* (2010), *Captain America: The First Avenger* (2010) and *Route Irish* (2010) shooting on location in and around the city. ✢

It's this ability to tell stories that helped to establish the city as the 'Hollywood of the North'.

A CASE OF COUP DE FOUDRE

Text by
ROGER
SHANNON

A Producer's Personal Perspective on Liverpool And Film

FRANCOIS TRUFFAUT once remarked that there was a certain incompatibility between the terms 'Cinema' and 'Britain'. Clearly, he had never been to Liverpool, where 'Liverpool and Film' has been a long standing coup de foudre. My love of and engagement with film began as a child in the Liverpool of the 1950s and it has continued to this day, taking in along the way roles such as producer, film fund head, financier, exec producer, film festival director and, more recently, Professor of Film and Television, Edge Hill University, at its creative campus on the fringes of rural Merseyside.

Around the World in Eighty Days was the first film I ever saw; it was in 1957 at the Regal Cinema in Litherland in north Liverpool when I was five. At seventeen I saw John Schlesinger's Midnight Cowboy in Waterloo, Liverpool – now the wonderful community cinema the Plaza – and that got me into 'Cinema'. I joined Merseyside Film Theatre in 1970 at the Bluecoats Arts Centre when I was eighteen and began watching international art cinema from then on. As a producer and funder at Liverpool's Moving Image Development Agency (MIDA) I was involved with a host of films shot in Liverpool. MIDA helped around sixty

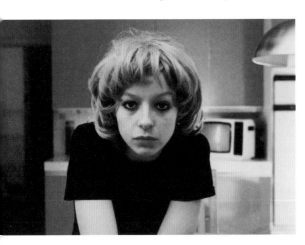

films get produced in Liverpool in the mid- to late 1990s; feature films, documentaries, shorts, TV drama series, pilots, the whole shooting match. I worked hand in glove with the Liverpool Film Office, an outcome of which was the strategy: 'The Film Office puts Liverpool in front of the camera – MIDA puts Liverpool behind the camera'. It was a strategy subsequently followed by many other cities and regions in the United Kingdom.

MIDA had a film production fund, which co-produced and co-financed a group of exciting independent UK films, all written, directed, produced and acted in by talented individuals just then appearing on the national and international film radar. Films like Butterfly Kiss (1995), the debut feature from director Michael Winterbottom and writer Frank Cottrell Boyce, Under the Skin (1997), director Carine Adler and producer Kate Ogborn's first feature, and Beautiful People (1999), Jasmin Dizdar's first feature film. With film industry awards for these films at the Sundance, Berlin and Cannes film festivals, the role of a funding and producing agency such as MIDA was paramount in attracting increasing attention to Liverpool as a city enraptured by film.

Under the Skin – which appeared in The Guardian's top twenty best British films 1984–2009 – featured a blistering debut performance by Samantha Morton and a wonderful cameo as the mother by the renowned Liverpool actress Rita Tushingham. This film, which won awards at numerous film festivals, including Sundance, Toronto and Edinburgh, effectively launched Samantha Morton's feature film career. The scenes shot at Lime Street station as she confronts her sister, played by Claire Rushbrook, about their dead mother's ring, are so combustive and combative that innocent passers-by are seen to recoil in shock at the dramatic venom Morton unleashes in her role as Iris, the sister beset by extravagant despair and headed for the oblivion of sexual recklessness. It was this instinctive and

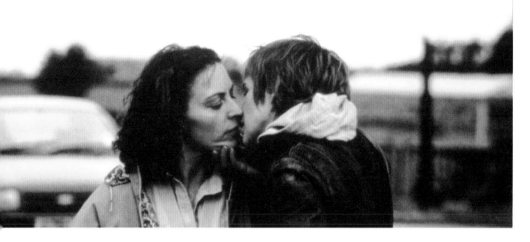

honest performance that persuaded Woody Allen to cast Morton in *Sweet and Low Down* for which she was Oscar-nominated.

I recall watching with astonishment, on a shipped-in Steenbeck, these blazing rushes with Kate Ogborn, the producer, and Ewa Lind, the film's editor, as they camped in a cramped office close to the Albert Dock, and set about post-producing the film. In my experience, producing in Liverpool comes ready-made with a safety net that goes by the name of the Liverpool Film Office, the first port of call for all producers embarking on a film in the city, and a 'one stop shop' for all manner of film-friendly advice and guidance. The city has had a Film Office since the mid-1980s, the very first in the United Kingdom to be affiliated to the Association of Film Commissioners International. This longevity brings with it a high level of professionalism for what can be realistically achieved in filming in the city, coupled with an awareness of how to work imaginatively with producers and directors to realize their creative ambitions. In the time I've been associated with filming in Liverpool, Lynne Saunders has been an ever-present and rigorously resourceful figure in the process of securing locations for producers, whilst making the task of filming in the city that much easier and more enjoyable.

At seventeen I saw John Schlesinger's *Midnight Cowboy* in Waterloo, Liverpool – now the wonderful community cinema the Plaza – and that got me into 'Cinema'.

As Head of MIDA I was keen on investing in 1995 in a three-hour-long BBC film drama, *Soul Survivors* starring Ian McShane, being made by independent producer Martyn Auty. With the main twelve-week shoot set to take place in Manchester, Martyn visited Liverpool intending to shoot just a few minor scenes in the city. After only an afternoon checking out locations he decided there and then to relocate the whole drama to Liverpool. Along with McShane the cast included a wealth of American 'faces': Isaac 'Shaft' Hayes, Antonio 'Huggy Bear' Fargas and Taurean 'Hill Street Blues' Blacque, all featuring as members of the Tallahassies, the best soul and R & B outfit ever to tour prime time BBC1.

For those twelve weeks Isaac Hayes lived in Liverpool, and generated the kind of 'hot-buttered' buzz that only he could muster whenever he stepped out into the city's clubs to DJ a set, or to check out the music being played by a fellow member of the crew. This he did with great regularity and generosity. To have Hayes turn up in some small club and catch your act was a rare treat for some of the younger Liverpool singers and musicians in the *Soul Survivors* cast. At the end of the shoot came one of my lesser known claims to fame. Hayes offered to auction his costumes from the production for charity. As master of ceremonies I auctioned off a pair of his boxer shorts and his dressing gown. The successful bidder, for a large amount of money, was Liverpool actress, Margi Clarke (starring as Connie in *Soul Survivors*). I hope she's wearing them still in honour of a unique individual, who will always be a soul survivor. ✛

LOCATIONS MAP

LIVERPOOL

maps are only to be taken as approximates

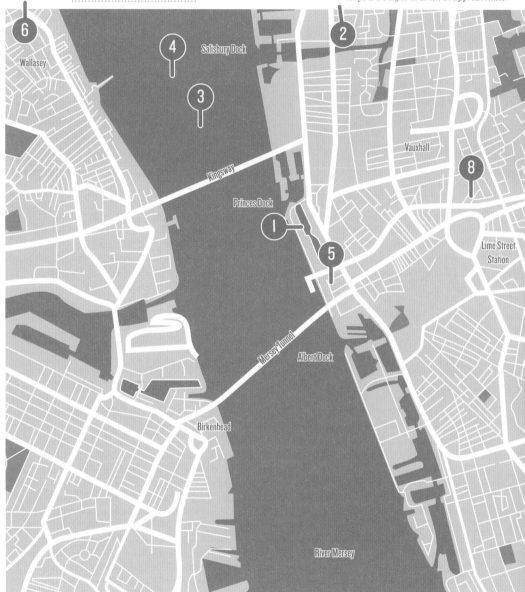

6
Wallasey

4
Salisbury Dock

3

2

Kingsway

Vauxhall

8

Princes Dock

1

5

Lime Street
Station

Mersey Tunnel

Albert Dock

Birkenhead

River Mersey

LIVERPOOL LOCATIONS
SCENES 1-8

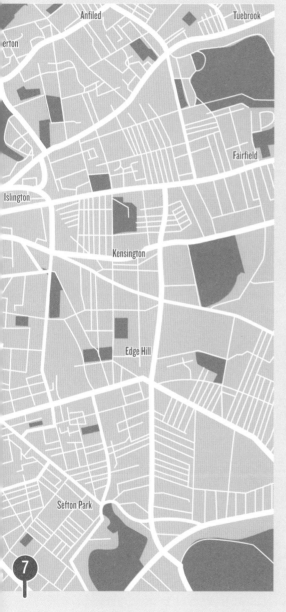

PANORAMA PRIS DU CHEMIN DE FER ÉLECTRIQUE I–IV (1897)

LOCATION *Liverpool Docks*

EMERGING FROM the industrial darkness of late Victorian Liverpool, the four short extracts that form *Panorama Pris du Chemin de Fer Électrique I–IV* are among the first moving images ever captured of the city. By mounting his camera in one of the carriages travelling along the Liverpool Overhead Railway Jean Alexandre Louis Promio, film operator for the Lumière brothers, created what is considered by many to be the world's first tracking shot. The filming took place a matter of months after the first showing of the Lumières' famous 50-second film *L'arrivée d'un train en gare de La Ciotat*, and while the Liverpool footage was not reported to have created a panic among its audiences as the earlier film was alleged to have done, the impression of travelling without moving and the phenomenon of motion blur must have been an arresting experience. The film grants us passage on a journey across a span of Liverpool's commercial maritime history; starting at Brocklebank Dock overlooking a timber yard and moving north to south, the footage takes in Canada Dock and the Canada Hydraulic Station Complex, the Manchester Ship Canal Great Western Railway Station at the end of North Carrier Dock, Sandon Dock full of large steam ships, going on past Bramley Moor Dock, Nelson Dock, Collingwood Dock, Stanley Dock and Clarence Graving Dock, past the gigantic Waterloo Warehouse and finishing at Princes Dock Station. The view is much changed since 1896 when the footage was shot; buildings were lost in the war, the overhead railway was closed in 1956, yet this port city endures. ↝ **Jez Conolly**

Photo © Tom Pennington

Directed by Jean Alexandre Louis Promio
Scene description: A train ride along the Liverpool Overhead Railway
Timecode for scene: 0:00:00 – 0:04:00

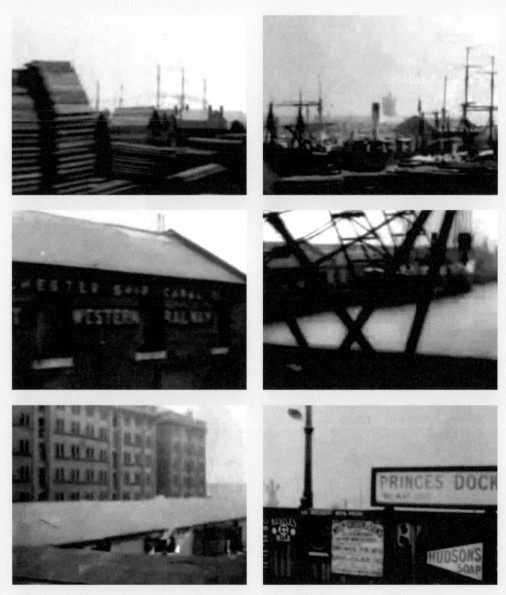

Images © 1897 Lumière

ARREST OF GOUDIE (1901)

Bootle Town Hall, Museum and Police Court, Oriel Road, Bootle

MITCHELL AND KENYON produced a number of innovative topical factual and fiction films following the founding of their film-making business in Blackburn in 1897, but their 1901 film *Arrest of Goudie* was something of a world's first. It is now regarded as the earliest example of a crime reconstruction, one that was shot on the very streets where the aftermath of the real misdemeanour took place. It depicts the arrest of Thomas Goudie, an employee of the Bank of Liverpool who embezzled £170,000 to pay off his gambling debts. Looking to capitalize on the public interest in the case, the film was exhibited at the Prince of Wales Theatre in Liverpool three days after Goudie's arrest in December of that year. It seems likely that a large part of the attraction of going to see the film was to give the local people an opportunity to watch themselves up on the screen, as Mitchell and Kenyon incorporated numerous crowd scenes in their short production. We see the key addresses involved in the case, on Berry Street and Church Street where Goudie hid or was apprehended, before eventually the criminal is seen being frogmarched off to the local police courts. Bootle Town Hall, opened in 1882 and designed in the Renaissance style by John Johnson who won the commission in a competition, served also as a courthouse and formed part of a complex of buildings erected during the late Victorian era as a declaration of Bootle's fierce civic pride. It is now a Grade II listed building. **Jez Conolly**

Photo © Paul Cartwright

Directed by Sagar Mitchell and James Kenyon
Scene description: The net closes in on the Liverpool embezzler
Timecode for scene: 0:00:00 – 0:04:38

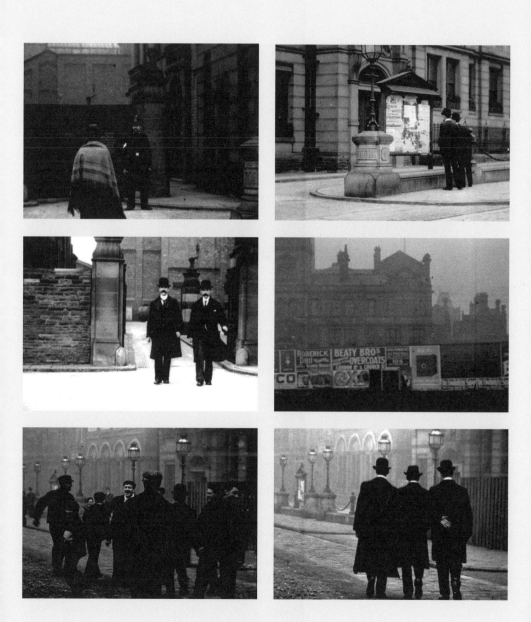

THE OPEN ROAD (1926)

The River Mersey

THE INTERWAR YEARS in Britain saw several instances of celebratory circumnavigation of the land, courtesy of the rapid rise in motor car ownership in the 1920s, records of the country that can be characterized as concerted attempts at reaffirmation of what it meant to be British. These often took the form of rather rose-tinted picture-postcard accounts, presenting an editorialized version of the country that was frequently at odds with the experience of most people's daily lives. The journalist H. V. Morton's bestselling 1927 book *In Search of England*, charting his tour around Britain in a bull-nosed Morris, was a case in point. A few years before Morton's book was published, the film-maker Claude Friese-Greene, son of the pioneering cinematographer William Friese-Greene, created his own record of Britain, a Lands End to John o'Groats tour filmed between 1924 and 1926 that formed the film *The Open Road*. Shot in Friese-Greene's two-colour film process Biocolour, it features Liverpool briefly, starting with a vehicle-mounted shot of the trams and traffic at the Pier Head then moving to the River Mersey where we encounter the captain of R. M. S. *Adriatic* on the deck of his ship before cutting to a shot of a sunset over the Irish Sea. Although fleeting, these colourful glimpses of the waters of the Mersey are enough to stir a sense of the river's importance in defining the character of the city, even if, by looking out to sea, Friese-Greene was turning a blind eye to the plight of many of the city's inhabitants at the time. ⟶**Jez Conolly**

Photo © Steve Daniels

Directed by Claude Friese-Greene
Scene description: 'The Mersey, the world's greatest maritime highway'
Timecode for scene: 0:24:02 – 0:25:06

From the deck of R.M.S. 'Adriatic' we viewed the Mersey, the world's greatest maritime highway.

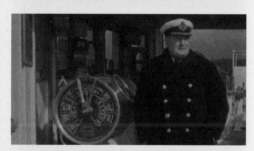

One of Liverpool's famous sea-captains, the skipper of the 'Adriatic'

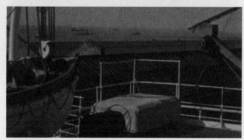

Stormy sunsets are appropriate for the Irish Sea

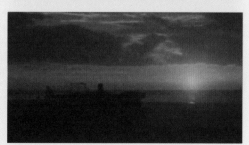

PENNY PARADISE (1938)

The Mersey tugboat 'Bonita'

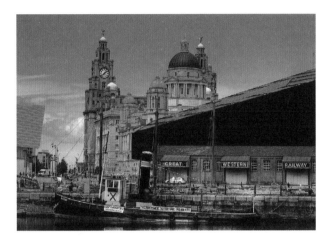

CAROL REED'S PROLIFIC contributions to cinema spanned four decades and began at a time when 'talkies' were gaining vast prominence throughout the world. The year 1938 saw the director team up with Basil Dean and Ealing Studios to create *Penny Paradise*, a lively send-up that sees a tugboat captain (Edmund Gwenn), believing himself the winner of a gambling fortune, celebrating his perceived new wealth. When the captain's first mate (Jimmy O'Dea) confesses to never collecting the winnings he was supposed to, Gwenn's newfound social status proves fleeting. Reed does an excellent job of introducing the rigours of a tugboat captain who yearns for something more. The opening sequence finds Gwenn and O'Dea's characters making their way along the River Mersey and Liverpool Bay. Theirs is a drop in the bucket surrounded by the much larger vessels as it's plain to see the scrappy men are looked down upon as a nuisance by their more powerful contemporaries. The coastal backdrop is complemented by the rocky waves of the Irish Sea as we meet our main players in the life with which they are most accustomed. It's not hard to see why the captain dreams of hitting it big playing the penny pools – the vast expanse of the Mersey, though beautiful, hints at an undertow that holds these men in its grasp. The tugboat 'Bonita' that features was an iron steam tug built in Sunderland in 1896. She sank in Liverpool's West Waterloo Dock on the night of 3–4 May 1941, at the height of the May Blitz on Liverpool. **Tim Kelly**

Photo © Steve O'Brien

Directed by Carol Reed
**Scene description: The Captain and his First Mate traverse
the comical perils of a crowded River Mersey
Timecode for scene: 0:00:00 – 0:02:55**

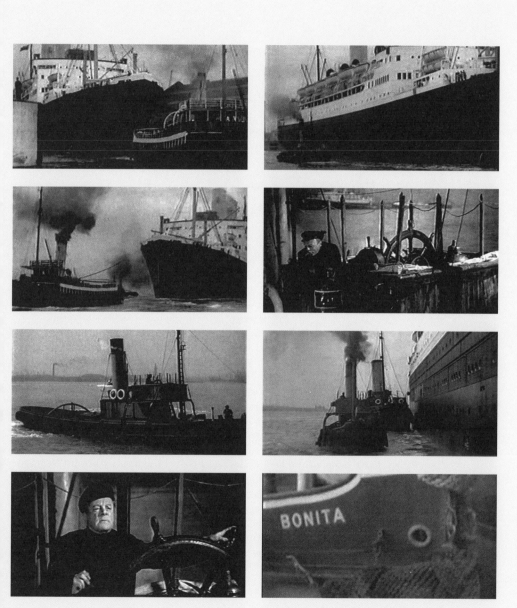

WATERFRONT (1950)

LOCATION *The Royal Liver Building, Pier Head*

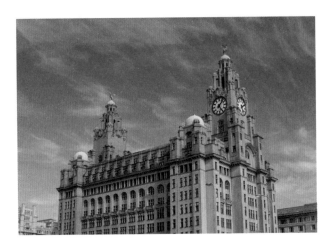

IN THIS EARLY SCENE from Michael Anderson's *Waterfront*, Ben, played by a young Richard Burton, and Nora, played by Avis Scott, are standing in the shadow of the Liver Building overlooking the Pier Head, perhaps the most iconic and recognizable building in the city. Ben has been unemployed for two years and since his engagement to Nora has begun to doubt that he has anything to offer her; 'I am using up your life ... I can't marry you,' intones Ben as the pretext for a way out of the relationship. Staring seawards, his moody demeanour and noirish Macintosh-and-felt-hat attire are complemented by Nora's femme fatale sultriness. With forces seemingly pulling them apart she reveals a ring on her left hand which is symbolic of their binding union. The scene is full of opposites: light and dark, male and female, uncertainty and certainty, echoed by the words of the characters of Ben and Nora ... that life without each other would be like the building behind them without its famous 'Liver Birds'. Built at the turn of the century for the Liverpool Lyver Burial Society which was founded to provide working men with the funding for a burial, the Royal Liver Building is widely known for the two winged symbols of the city that sit atop its clock towers. The metal sculptures of the cormorant-like birds, designed by Carl Bernard Bartels and constructed by the Bromsgrove Guild, are said to be male and female, with the male looking towards the city and the female looking out to sea. ⟶*Linda Jones*

Photo © Eddy Lloyd

Directed by Michael Anderson
Scene description: Two Liver Birds contemplate the future
Timecode for scene: 0:17.32 – 0:18.44

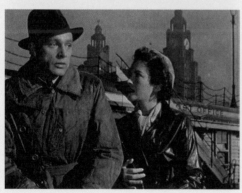

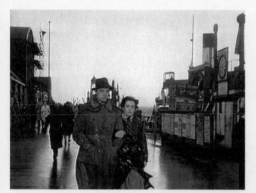 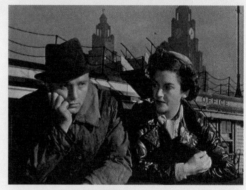

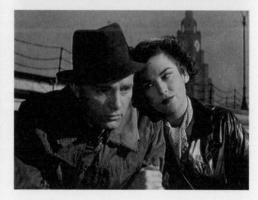

Images © 1950 Paul Soskin Productions

THE MAGNET (1950)

Palace Amusement Arcade, Marine Promenade New Brighton, Wirral

A DELIGHTFUL ROMP exploring how fraught with mischief one's youth can be, *The Magnet* recounts the story of Johnny (a young James Fox in his first starring role). Quarantined from school after a scarlet fever outbreak, young Johnny entertains himself in the form of the titular magnet, which he swaps with a young boy for an 'invisible watch'. As Johnny's guilt gets the best of him he finds that a clean conscience can be hard to come by. Chastised by his nanny for his shenanigans, he runs off in an effort to dispose of this new toy – one that's brought him only grief. But doing so only brings more trouble. Much in the way he procured his magnet, Johnny finds himself taken advantage of by a boy older than he – in the heart of the Palace Amusement Arcade no less. Together, Johnny and this elder scamp conspire to use the magnet to cheat at pinball and split the winnings. This serves only to further Johnny's guilt however, as the boys are quickly caught by the owner. Not one to shoulder the blame, the older boy is fast to blame his new friend and escape back into the bustle of a crowded arcade. Amidst the chaotic pings of games and melodic tunes emanating from the merry-go-round, Johnny once again finds himself alone and at the mercy of an adult. An almost heartbreaking juxtaposition when surrounded by the excitement of such lively grounds.
⬗ Tim Kelly

Directed by Charles Frend
Scene description: Johnny's magnet is used to cheat at Palace Amusement Arcade
Timecode for scene: 0:17:40 – 0:19:31

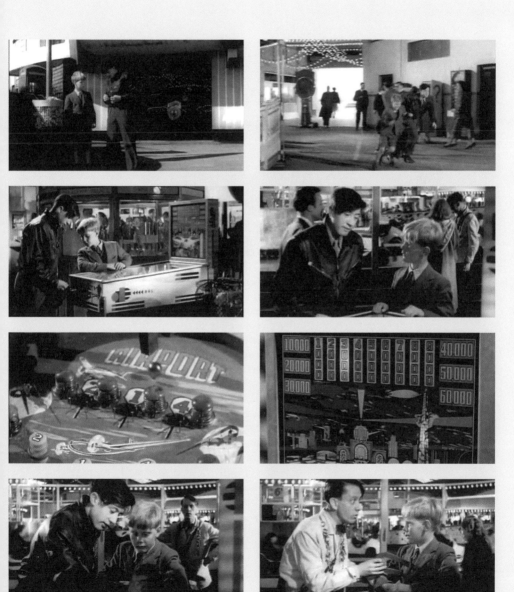

THE CLOUDED YELLOW (1950)

LOCATION *Dingle Tunnel, entrance in Kedleston Street*

IN THE TRADITION OF great suspense cinema, *The Clouded Yellow* sees former British Secret Service agent David Somers (Trevor Howard) on the run and in the company of a suspected murderer. What begins as a simple job cataloguing butterflies (from which the film derives its title) soon descends into danger as a gamekeeper is murdered and suspicion falls on the beautiful and seemingly dangerous Sophie Malraux (Jean Simmons) – niece of his caretakers and object of David's gaze. Drawn by her eccentricities as much as her beauty, David attempts to protect the wrongfully accused Sophie and keep both of them one step ahead of the investigators. As the figurative noose grows ever tighter, their cross-country escape finds Somers apprehended with Sophie on the run and without her seasoned protector. It's in this moment that the real murderer reveals himself and makes his move to silence Sophie. The drama resolves on the Liverpool Overhead Railway, where Sophie flees to escape the clutches of her would-be killer. David once again manages to be his love's saviour, rescuing Sophie from a terrifying demise as their enemy falls victim to a train. Safe from persecution and their freedom ensured, the railway is a fitting setting and an even more fitting end for the viewer; we've watched David's feelings toward Sophie cross the tracks from fascination to, quite certainly, love. And while the railway itself has fallen to time – the surviving entrance to Dingle Tunnel features above – its impact and importance to this film are undeniably memorable. ⤜ *Tim Kelly*

Photo © Paul Cartwright

Directed by Ralph Thomas
Scene description: David saves Sophie from the clutches of her killer
Timecode for scene: 1:17:25 – 1:21:12

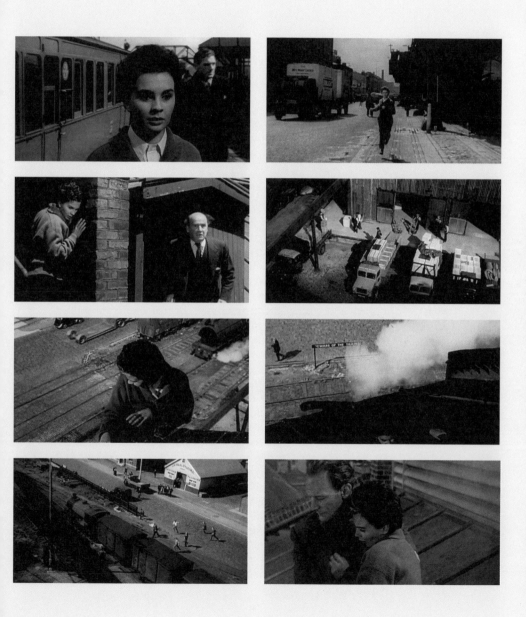

VIOLENT PLAYGROUND (1958)

Gerard Gardens, Christian Street/Hunter Street

DIRECTED BY BASIL DEARDEN, 1958's *Violent Playground* was offered up as Great Britain's alarmist response to *Blackboard Jungle*. This condemnation of youth revolt is rife with sociopolitical meditation but skewed by its explicit agenda to fan the flames of growing fear inspired by juvenile delinquency. Though it serves as a tainted snapshot of the times, *Playground* perhaps unknowingly reveals honesty in its depictions of economic squalor and depravity. This is no more evident than when we come upon Gerard Gardens. Detective Sergeant Jack Truman (Stanley Baker) is tasked with familiarizing himself with local delinquency only to be drawn into the youth gang culture on a deeply personal level. It is in this early scene that Truman first comes upon Johnny Murphy (David McCallum), who in time will become the subject of the detective's arson investigation. Immersed within the concrete sprawl of the Gardens, Johnny's position of power comes through in his relaxed, dissociative state. Skipping stones and chipping away at a weathered teddy bear tied to a post, Dearden framed Johnny in a manner that conveys simmering volatility. Given the director's intentions, it's an effective introduction to both Johnny and his environment. Though the Gardens have long since been demolished, the Hod Carrier monument found on a plinth at the corner of Christian Street and Hunter Street serves as a reminder to the community that once stood there. It is a replica of the original sculpture, which having been spared the wrecking ball, now resides at the Museum of Liverpool. •► *Tim Kelly*

Photos © Paul Cartwright

Directed by Basil Dearden
Scene description: Johnny holds court in the slums of Gerard Gardens, the titular playground
Timecode for scene: 0:12:30 – 0:13:42

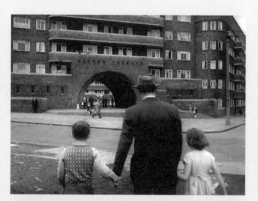

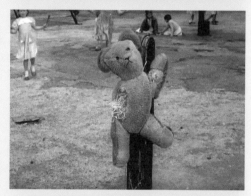

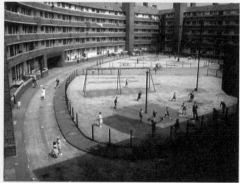

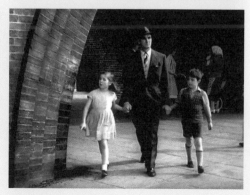

WITH HOPE IN YOUR HEART

Scouse Sport On-screen

Text by
DAVID
PARKINSON

ONE EVENT DOMINATES the relationship between cinema and Liverpudlian sport and it took place 1706 miles away from the city itself. However, Merseyside had established its screen-sporting credentials long before 25 May 2005.

The drama, passion and glorious unpredictability of sport have always been notoriously difficult to recreate on film with any degree of immediacy and authenticity. It's perhaps fitting, therefore, that many of the greatest moments in Mersey sport have been played out by genuine idols and captured by newsreel, documentary and/or television cameras. Mitchell and Kenyon shot the earliest extant footage of the derby between Everton and Liverpool, as the Blues notched up a 3–1 win at Goodison Park in 1902. Yet, while this fixture continued to attract British Pathé crews into the 1960s, it was the Grand National at Aintree that became the region's most filmed sporting occasion.

Following Kirkland's success in the 1905 race, newsreel clips quickly found a global audience, with Hollywood being sufficiently familiar with the gruelling four-and-a-half-mile steeplechase for MGM to adapt *National Velvet* (Clarence Brown, 1944), Enid Bagnold's 1935 novel about a Sussex girl's dream to take her horse to Aintree. With

jockey Mickey Rooney indisposed, Elizabeth Taylor disguises herself to ride The Pie to victory, a feat that was matched against even more overwhelming odds by Bob Champion when he overcame cancer and his mount, Aldaniti, recovered from a potentially crippling leg injury to win the National in 1981.

Their story was emotionally told in the biopic *Champions* (John Irvin, 1983). But Aintree has been the scene of more whodunnits than heart-warming dramas, with owner Nigel Patrick struggling to convince Inspector Michael Hordern of his alibi following his wife's murder in *Grand National Night* (Bob McNaught, 1953) and rider Scott Anthony fighting a crooked betting syndicate in Tony Richardson's 1974 take on the Dick Francis thriller, *Dead Cert*.

Aintree also hosted half a dozen Formula One motor races, with Pathé recording Stirling Moss becoming the first home winner of the British Grand Prix in 1955. The same company also followed fabled golfers Walter Hagen, Bobby Jones, Peter Thompson and Arnold Palmer during their triumphant Open championship visits to the Royal Liverpool club at Hoylake and the Royal Birkdale course further up the coast in Southport. As local heroes like Pat McAteer won their titles, boxing also proved a newsreel staple, while documentarist Steve Read more recently charted the efforts of Tom Stalker, Natasha Jonas and Jazza Dickens to make the London Olympic squad in *Knockout Scousers* (2012).

The Games have their place in Mersey screen folklore, as the Bebington Oval on the Wirral stood in for Paris's Olympic Stadium in Hugh Hudson's *Chariots of Fire* (1981). Nearby Ellesmere Port was also home to Wirral FC, the fictitious club run by Ricky Tomlinson in the ITV sitcom *Mike Bassett: Manager* (2005) following his ignominious spell in charge of the national team in Steve Barron's 2001 feature *Mike Bassett: England Manager*. But the footballing focus has

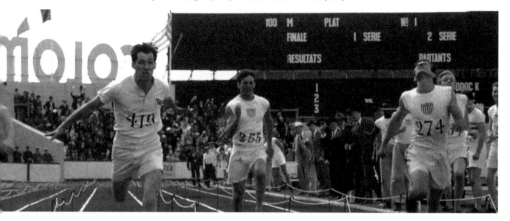

fallen more frequently on the clubs across the water divided by Stanley Park.

While Bill Shankly was masterminding the Red Revolution at Anfield, Harry Catterick was quietly assembling one of the finest teams in Everton's history. But the 1963 championship win was somewhat marred by the scandal that broke around wing-half Tony Kay, who had placed a £50 bet on a game in which he had played while at Sheffield Wednesday. The sorry saga was recalled with laudable tact by Paul Greengrass in the BBC teleplay *The Fix* (1997), which starred Jason Isaacs as Kay and Colin Welland as Catterick, who had appeared as himself in *The Golden Vision* (1968), Ken Loach's masterly small-screen tribute to the average fan that also provided a poignant insight, through its profile of Scottish striker Alex Young, into the realities of being a professional footballer in the pre-Sky era.

The ardour shown by Ken Jones, Bill Dean and their pals as they travel south to support the Toffees at Arsenal is equally evident in Paul Duckworth's household in Ian Lysaght's *Reds & Blues: The Ballad of Dixie & Kenny* (2010). When not drowning his sorrows in the Bitter and Twisted pub, Duckworth is trading insults over the garden fence with diehard Koppite Andrew Schofield. Scripted by Dave Kirby, this bawdy musical farce makes much of Liverpool's struggle to regain their supremacy of the 1970s and 1980s, which came to an end around the time of the stadium tragedies in Brussels and Sheffield, which were respectfully recalled in Marco Tullio Giordana's *Appuntamento a Liverpool* (1988) and Charles McDougall's Jimmy McGovern-scripted TV-movie, *Hillsborough* (1996).

Although Heysel tarnished the reputation of Liverpool, the club retained a fervent following around the world, with its popularity in Scandinavia being reflected in Mårten Klingberg's comedy *Offside* (2006), which sees a washed-up former Red reinvigorate a languishing Swedish league team, and Arild Andresen's charmer *The Liverpool Goalie* (2010), in which a Norwegian tweenager learns some vital life lessons while chasing the Pepe Reina card he needs to complete his collection. But the predominant movie theme is Liverpool's astonishing Champions League victory over AC Milan, which saw them lift the trophy on penalties after trailing 0–3 at half-time.

Manager Rafael Benitez's team talk has been immortalized (and more than a little mythologized) by actor Neil Fitzaurice and writer Dave Kirby in Illy's *15 Minutes That Shook the World* (2009), a rousing featurette that co-stars Steven Gerrard and Jamie Carragher, who also crop up alongside Kenny Dalglish in Ellen Perry's *Will* (2011), a sentimental road movie that follows an 11-year-old orphan across Europe clutching the final ticket purchased for him by his late father. But nothing better conveys the sense of disbelief and euphoria experienced by the fans than the 2011 DVD record of a lively Liverpool Empire performance of Nicky Alt's hit play *One Night in Istanbul*, which provides proof positive of the enduring Kop anthem `You'll Never Walk Alone' in centring on two middle-aged supporters as they try to remain on the right side of the law while regaling their sons of their scurrilous European Cup exploits. ✠

The drama, passion and glorious unpredictability of sport have always been notoriously difficult to recreate on film with any degree of immediacy and authenticity.

LIVERPOOL

maps are only to be taken as approximates

10

Wallasey

Salisbury Dock

16

Vauxhall

Kingsway

Princes Dock

9

Lime Stree Station

13

Mersey Tunnel

Albert Dock

Birkenhead

11

River Mersey

14

LIVERPOOL LOCATIONS
SCENES 9-16

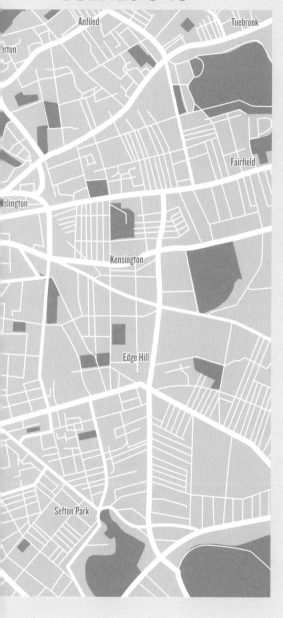

BEYOND THIS PLACE (1959)

LOCATION *Picton Library, William Brown Street*

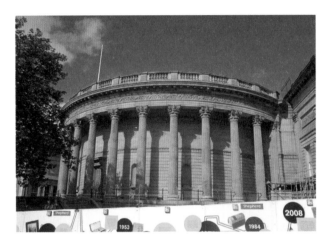

BASED ON A. J. CRONIN'S novel of the same name, *Beyond This Place* finds Paul Mathry (Van Johnson) piecing together the details of a murder for which his father has been tried and convicted. A childhood native returning from the States for a brief visit, Paul is distraught to discover the father he believed had died a war hero is not only alive, but rotting away in prison. The narrative sees Van Johnson's character grow from aimless wanderer to active crusader as he resolves to find the true culprit of a crime that left a woman dead. Early on, his quest finds him navigating the illustrious architecture of Picton Library. Completed in 1879, it was the first electrically lit library in the United Kingdom. Seeking illumination but not knowing where to begin, Paul decides to check the local papers on the date of the murder to see if they can provide useful information. To that end, he's assisted by Lena, a librarian in Picton's circular study. Paul works tirelessly into the night piecing together what little information he can. The papers serve as but little clues that will ultimately lead him to the truth, and director Jack Cardiff could not pick a more visually appealing setting as Paul's adopted-American roguishness clashes with the rich and storied surroundings of Picton. It's not long before closing time and he finds himself being shuffled out the door at Lena's behest. But serendipity still has a role to play, as Paul and Lena leave together, unknowingly embarking on the adventure that lies ahead. **•➤ Tim Kelly**

Photo © Paul Cartwright

Directed by Jack Cardiff
Scene description: Paul enters Picton Library
and begins piecing together the details of his father's crime
Timecode for scene: 0:11:08 – 0:14:35

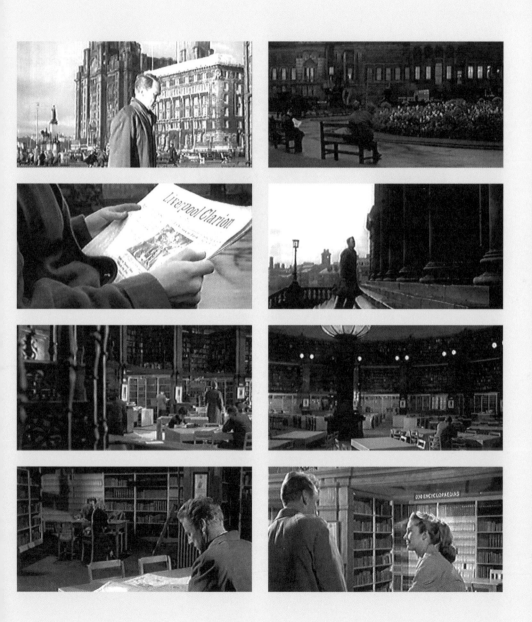

I THANK A FOOL (1962)

LOCATION *New Brighton funfair, Wirral*

IN THIS SCENE from the underrated Hitchcockian crime melodrama, attorney Stephen Dane's (Peter Finch) disturbed wife Liane (Diane Cilento) runs away from the confines of the Dane household and is seen enjoying the thrill of a fairground Ferris wheel to the intoxicating sound of rock and roll music. Ex-doctor Christine Allison (Susan Hayward) – first prosecuted by Dane on a charge of assisted suicide then subsequently employed by him upon her release from prison to look after his wife – has followed Liane to the fair with the intention of bringing her back to the safety of the family home. The scene foreshadows one of the final moments of the film when the appropriately named Captain Ferris (Cyril Cusack), Liane's father, falls to his death and is seen lying dead upon a slowly rotating playground roundabout. The saturated colours of the fairground scene contrast with the muted green and brown tones of the Dane house, and are captured at their best by a stunning panoramic aerial shot, courtesy of cinematographer Harry Waxman, which makes great use of the widescreen ratio and takes in the whole of the New Brighton funfair where the scene was filmed. Situated on the tip of the Wirral Peninsula, separated from Liverpool by the River Mersey, New Brighton was Liverpool's answer to New York's Coney Island, a place for the working classes to leave behind the shackles of their jobs and lose their inhibitions at the carnival. The funfair sadly fell into decline during the 1960s and 1970s and the Ferris wheel was dismantled. **Caroline Whelan**

Photo © Paul Cartwright

Directed by Robert Stevens
Scene description: Liane rides on the Ferris wheel at New Brighton
Timecode for scene: 0:43:14 – 0:45:51

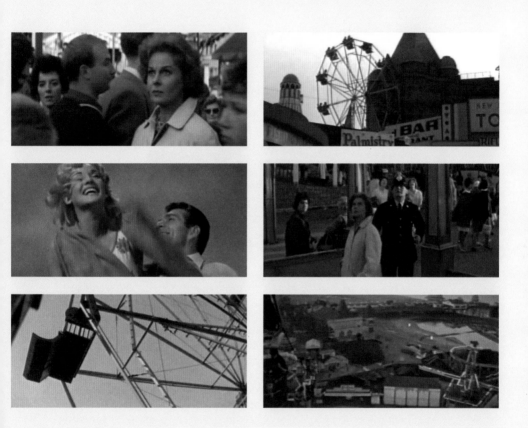

FERRY CROSS THE MERSEY (1965)

LOCATION *The Mersey Ferry*

SHOT IN A HURRY to capitalize on a successful US tour by Gerry and the Pacemakers, *Ferry Cross the Mersey* flashes back to a highly fictionalized version of the band's early days in Liverpool. Gerry is living with his Auntie Lil (Mona Washbourne) and struggling to combine gigging with his art school studies. As part of a 'day in the life' sequence, we see him ride his scooter to the Royal Iris ferry where he crosses the river to get to the college. On board, he meets up with his bandmates and they discuss new song ideas for a band contest. The film's vaguely realist mode then loosens somewhat as band member Les Maguire pulls up a piano and they launch into a rendition of 'Ferry Cross the Mersey' (which Marsden wrote for the film), while the titular boat plies the waters. Gerry becomes a strolling player, serenading sundry passengers as he drifts off from the band and tours the deck (dealing realism another blow in this pre-roving-mic era). When the song ends, so does the crossing: after a few shots of mooring ropes and machinery, Gerry and the band ride their scooters down the gangplank at Albert Dock. This boat trip reinforces the band's image as resolutely local: 'Here I'll stay', runs the repeated refrain at the end of the song. Indeed, this and their cover of Rodgers and Hammerstein's 'You'll Never Walk Alone' have become linked with the Liverpool community in a way that no song by the Beatles ever has.
➥**Nick Riddle**

Photo © Paul Cartwright

Directed by Jeremy Summers
Scene description: The band aboard
Timecode for scene: 0:14:14 – 0:19:03

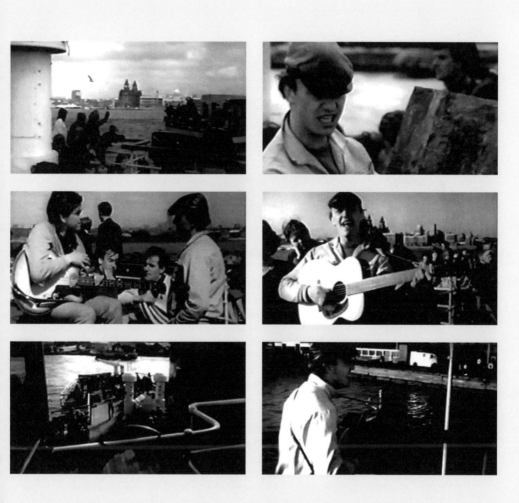

YELLOW SUBMARINE (1968)

(A fictionalized, animated version of) Hope Street

OVERCOME BY DEPRESSION, Ringo Starr shuffles around Liverpool. 'I'd jump in the Mersey,' he says. 'But it looks like rain.' The scenery behind him (which is, at least by *Yellow Submarine*'s standards, a dreary and realistic rendering of the city) is a striking contrast to the psychedelic spectacle of Pepperland, where we have spent the opening ten minutes of the movie. Pepperland has been invaded by the Blue Meanies and the eponymous submarine has escaped in search of help from The Beatles. We cut to Hope Street. Its famous sign lingers on-screen. Ringo enters, pursued by the submarine. He sees something but, whenever he turns around, it disappears. He walks on. Home to, among other notable buildings, the Liverpool Philharmonic, the Liverpool Medical Institute, two cathedrals (Catholic and Anglican) and the Everyman Theatre, Hope Street is one of the most culturally significant sites in the city. The vibrant area around it is known as the Hope Street Quarter; the Hope Street Association exists to promote it; and the Hope Streets Feast exists to celebrate it. But its appearance in *Yellow Submarine* gives it a special kind of Liverpudlian celebrity, one that only comes from association with The Fab Four. Few real-life locations make it onto film in such an unusual way: *Yellow Submarine* is one of twentieth-century cinema's strangest works of surrealism. Astonishingly, though, the scene in which Ringo Starr is followed down Hope Street by a flying submarine is one of the least bizarre in the film. **➺ Scott Jordan Harris**

Photo © Peter Hodge

Directed by George Dunning
Scene description: *Hopeless on Hope Street*
Timecode for scene: 0:12:50 – 0:13:40

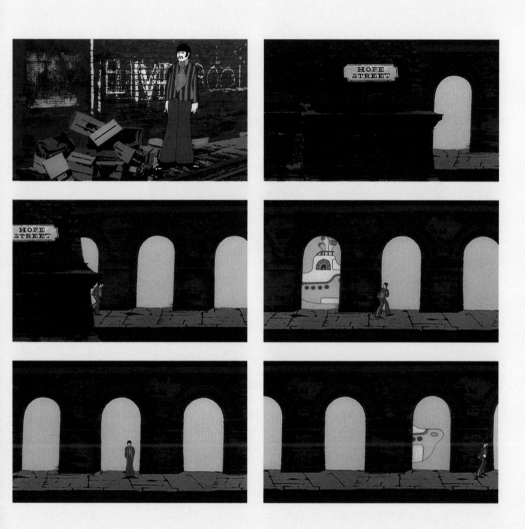

GUMSHOE (1971)

The Cunard Building on Liverpool's Pier Head waterfront

GUMSHOE WAS RELEASED IN 1971, a few years after Liverpool took the sounds of American youth, made its own thing of it, and exported it to the world. Having tired of his life as a failing comedian on the lower rungs of the nightclub scene, Albert Finney's character, Eddie Ginley, attempts a cultural appropriation of his own. He strives to become a hard-boiled private eye modelled on his favourite literary sleuth, Sam Spade, though his character owes more to the nobility and weary compassion of Philip Marlowe than to the wolfish and cynical Spade. The necessary parts are in place; a mysterious package containing money, a gun and a photo of a beautiful young girl. There are threatening visits from various heavies and wise-cracking dialogue. Eddie, however, also has to contend with a family connection to the case through a resented sibling who married his own sweetheart, as well as his faltering career. The cityscape flatters to deceive as much as the other elements of the movie. Close interiors of frosted-glass doorways and shadowy bookshops serve the noirish inspiration. Wider exteriors betray the drab look of neglected 1970s England. One shot, however, of Eddie walking past the Cunard Building, one of the Pier Head's 'Three Graces', across the street into another doorway, manages to evoke the look of a 1940s noir with the imposing stone structures and monolithic doorway dwarfing the windswept aspiring gumshoe. It is a shot that brings to mind Raymond Chandler's timeless *quote* about mean streets walked by a man who is not himself mean.

⚹ David Owain Bates

Photo © Paul Cartwright

Directed by Stephen Frears
Scene description: Eddie Ginley walks past the Cunard Building
Timecode for scene: 1:02:43 – 1:02:56

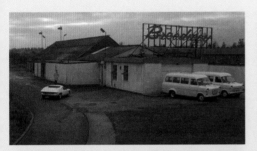 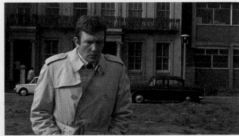

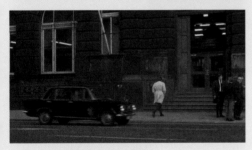 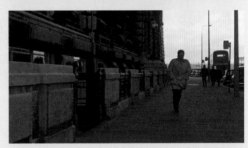

 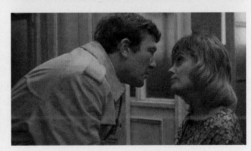

CHARIOTS OF FIRE (1981)

The Oval Sports Centre, Old Chester Road, Bebington, Wirral

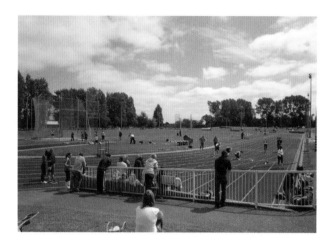

THE 400 METRE FINAL is the sporting culmination of *Chariots of Fire* and also serves as its thematic summation. Having missed the opportunity to compete against Harold Abrahams (Ben Cross) in the 100 m – his Christian principles refused to allow him to run on the Sabbath – Scot Eric Liddell (Ian Charleson) lines up for the consolation event that was far from his specialist distance. His devout sister Jennie (Cheryl Campbell), who had wanted him to quit running and emulate their parents by becoming a missionary in China, encourages him from the stands, along with dignitaries like Lord Birkenhead (Nigel Davenport) and the Prince of Wales (David Yelland), who had urged him to put king and country before God. Prior to the race, American athlete Jackson Scholz (Brad Davis) hands Liddell a note applauding his moral stance – a gesture at odds with the dismissive arrogance of the US coach at trackside. As Liddell strides to triumph, a vocal flashback recalls his conversation with Jennie justifying his decision to compete – `I believe God made me for a purpose, but he also made me fast. And when I run I feel His pleasure' – a sentiment that contrasts strikingly with Abrahams's relentless pursuit of glory. The Oval Sports Centre at Bebington on the Wirral stood in for the Stade Olympique de Colombes, as its grandstands looked suitably antiquated and it lacked anachronistic floodlights. Indeed, Merseyside was busy throughout the production, with the nearby Woodside ferry terminal standing in for Dover and Liverpool Town Hall doubling for the British Embassy in Paris. **»David Parkinson**

Photo © Paul Cartwright

Directed by Hugh Hudson
Scene description: Eric Liddell wins the 400 m at the 1924 Paris Olympics
Timecode for scene: 1.47.15 – 1.51.40

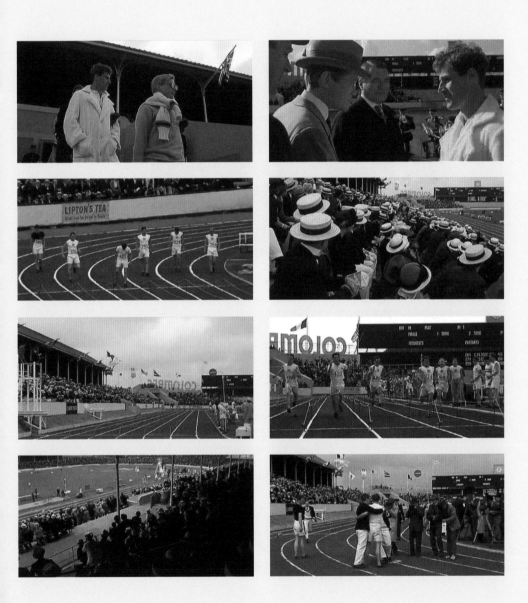

EDUCATING RITA (1983)

Trinity College, Dublin's city centre, Ireland

ALTHOUGH SET IN LIVERPOOL, *Educating Rita*, based on Willy Russell's play, was filmed entirely in Dublin city. The campus of Trinity College, Dublin's oldest university, was used as the film's university location. This early scene depicts main character Rita (Julie Walters) as she makes her entrance for the first time onto the university campus. Although situated right in the centre of Dublin, Trinity, like many city universities, is a place not owned by all its citizens. The grass roots Liverpudlian Rita, by pursuing a university course, is breaking through some of the social and economic barriers that can exist between higher education and working-class people. Framed in the doorway leading to the front square, in a shot reminiscent of the iconic image of John Wayne at the end of John Ford's *The Searchers*, Rita crosses the threshold into the campus and in doing so passes from light to darkness and back into light. Stumbling across the old cobblestones in her high heels and pencil skirt, like a Fresher out of water, Rita appears uncertain and does not know where to go. However tentative, these are the first steps on a journey significant for the barriers that she breaches and the personal obstacles that she overcomes. David Hentschel's musical score anticipates her journey's end, suggesting the procession of the graduates to receive their awards. Not only will Rita gain from her experience, she will bring a breath of fresh air that will blow away the stuffiness of her professor and the smugness of her fellow students. ➽ *Díóg O'Connell*

Photo © Bjørn Christian Tørrissen

Directed by Lewis Gilbert
Scene description: Rita arrives on her first day at Trinity College Dublin
Timecode for scene: 0:04:09 – 0:04:55

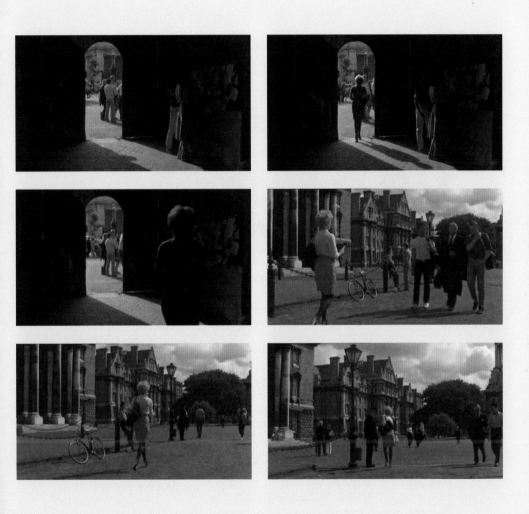

CHAMPIONS (1983)

LOCATION *Aintree Racecourse, Ormskirk Road, Aintree*

THERE'S LITTLE WONDER that Bob Champion won the 1981 Grand National aboard Aldaniti, as, after the battle to regain fitness that each had endured, formidable obstacles like Becher's Brook and The Chair must have seemed like gymkhana hurdles. The chestnut gelding had damaged a tendon while Champion was being treated for cancer. But the owner refused to have the 10-year-old destroyed and his recovery coincided with Champion's heroic return to National Hunt racing. Adapted from *Champions Story*, the autobiography co-written with Jonathan Powell, this well-intentioned biopic conveys the courage and obduracy the jockey displayed throughout his illness. But it's the air of calm assurance that Champion (John Hurt) displays while walking the course on the morning of the race that is most striking in a scene that opens with a hazy dawn view across Aintree as Aldaniti (playing himself) tests the lush turf. Discussing tactics as they stroll, Champion and trainer Josh Gifford (Edward Woodward) reach The Chair, where the sight of children playing on the wooden frame edging the six-foot ditch sufficiently unnerves owner Nick Embiricos (Peter Barkworth) and his wife Valda (Ann Bell) that they almost wish they could spare their beloved horse his ordeal. Champion jokes that Aldaniti will relish the 5 ft 3 in. hedge, as it will give him something to think about. But the shot of a stretcher being readied warns viewers of the dangers lying in wait and the contrast between this placid sequence and the brutal reality of negotiating the fence during the National itself is quite terrifying. **David Parkinson**

Photo © Paul Cartwright

Directed by John Irvin
Scene description: Bob Champion walks Aintree on the morning of the National
Timecode for scene: 1.25.44 – 1.28.40

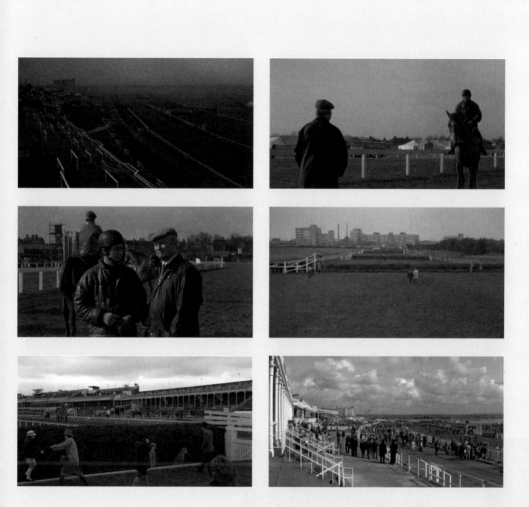

I KNOW A PLACE ...

Terence Davies's Liverpool

Text by
WENDY
EVERETT

TERENCE DAVIES'S LIVERPOOL is a city of profound contrasts and intriguing ambiguities, a haunting, mobile, inner/outer topography which simultaneously shapes and is shaped by his personal memories and experiences. Providing the setting for all his autobiographical films *The Trilogy* [1976–83], *Distant Voices, Still Lives* [1988] and *The Long Day Closes* [1992]), Liverpool moves to the foreground in *Of Time and the City* (2008), Davies's feature-length documentary, made in celebration of the city's status as European Capital of Culture.

Despite the wider perspectives of the documentary – after all, this is Liverpool revisited after an absence of nearly forty years – the city's emotional and temporal tensions are largely unchanged. But, however familiar this city seems to spectators of Davies's work, it would still be impossible to map it coherently for, like all his narratives, it is elliptical and temporally fluid; a city woven from the processes of remembering, a complex imprint of time itself.

Given the importance of music throughout Davies's work, and his repeated insistence that film is most successful when it is structured as

music, it is interesting to consider Liverpool too in such terms: city as urban symphony, structured by the rhythms and melodies of its intimate, secret spaces; iconic landmarks; and dense and complex history; an architectural construct based not on spatial logic but on shifting patterns of repetition and counterpoint. The tensions between the multiple times and spaces of the city establish a powerful dynamic which weaves together themes and motifs, past and present. Like the 'songlines' of Aboriginal mythology, Davies's films sing into existence his and his city's shared identities.

In this symphonic Liverpool, certain key motifs recur (the ironic counterpointing of images and music, tender close-up shots of elderly hands and faces, long sequences of children at play, for instance), while thematic passages emerge, develop and modulate. The theme of time and memory is fundamental, shaped by the often discordant juxtaposing or overlaying of past and present, creation and decay, hope and despair; for if, as Davies suggests, the past seems irrevocably lost, the film demonstrates that it is still powerfully present in the remembered spaces of the city. While the documentary begins with references to the 'blue remembered hills' of childhood, that 'land of lost content', it simultaneously transports us into that past, which becomes our present reality. To quote T. S. Eliot's *Four Quartets*, whose lines weave their way throughout Davies's voice-over commentary: 'Time present and time past / Are both perhaps present in time future / And time future contained in time past'. The haunting presence of the past is the most striking feature of Davies's Liverpool, a city imprinted by its remembered sites, voices, historical events and communities. At its vibrant heart, therefore, is a powerful, structuring absence.

The four main themes of Davies's childhood Liverpool: home, school, church and cinema continue to shape his present-day city, albeit in modulated form. The close-knit working-class, Irish Catholic community in which he grew up, its

poverty transformed by the maternal presence, by the songs, chatter and laughter that filled the small terraced house and street (18 Kensington Street, long since demolished) forms the home key of Davies's symphonic Liverpool; the place to which we repeatedly return. It is this 'absent' Liverpool that shapes our readings of the new cityscape: the lonely, soulless estates and high-rise flats that, for Davies, illustrate 'the British genius for creating the dismal' and powerfully reveal the failure of post-war slum-clearance schemes. Essentially, such places preclude the possibility of community, which Davies presents as one of Liverpool's richest resources. Similarly, the architectural splendour of Liverpool's great civic buildings, whose beauty is acknowledged by the images on screen, is uncomfortably marked by discordant undertones from Davies's past: his struggle to come terms with being gay at a time when state and church condemned homosexuality as, respectively, a criminal offence and a mortal sin. In the *Trilogy*, we see how, as a young man, Davies was forced to inhabit a sordid, subterranean world of illegal clubs and public lavatories, banished from the respectable sites and streets of the city, and his continuing anger and pain are keenly felt in depictions of, for example, the soaring interior of the Metropolitan Cathedral of Christ the King.

Davies's Liverpool is thus ambiguous, a city which he both loves and hates. As we have seen, his roots and sympathies are with the working class and this strongly colours his perspective. For him, Liverpool's heart, the city's identity, is not architectural and spatial but social: the indomitable spirit and ready wit of its inhabitants. It is also, and essentially, a female city, a city of domestic interiors and intimate gestures, of laughter and joy, and it is significant that the only voices we hear in *Of Time and the City*, apart from Davies's own, are those of generations of women as they work, chatter, or recount their life-stories. Far from being a sentimental and nostalgic city, however, it is vibrant, rebellious and politically charged. Davies uses Liverpool to highlight the corrupt inequalities of British society; he contrasts the extreme hardship of the working class in post-war Britain with the uncaring opulence of Royal ceremonies, and the modest needs of the poor with the greed of those in power.

However, above all, Davies's Liverpool is cinematic. It was here that, as a child, he discovered cinema (*Singin' in the Rain*), and that he found his personal salvation and identity. That so many of the cinemas of the past have closed down is one of the city's saddest losses, and yet they are still present through the remembered films of his youth, whose magic sounds and images still shape and colour the cityscape: *Seven Brides for Seven Brothers*, *Young at Heart*, *All that Heaven Allows*, an endless litany of the delights that he 'swallowed whole'. Davies's Liverpool is, in all senses, a cinematic construct: a celluloid creation of music and movement. He structures this city from his memories and dreams so that in its complex, ambiguous spaces, we can each, individually, find our own. ✠

The haunting presence of the past is the most striking feature of Davies's Liverpool, a city imprinted by its remembered sites, voices, historical events and communities.

LOCATIONS MAP

LIVERPOOL

maps are only to be taken as approximates

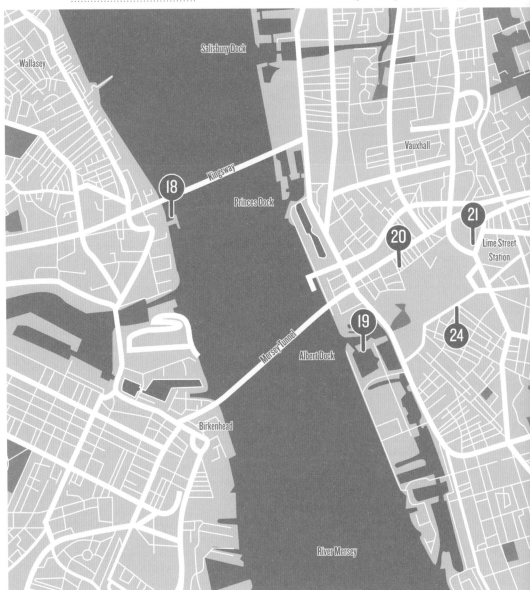

Wallasey

Salisbury Dock

Vauxhall

Kingsway

18

Princes Dock

21

Lime Street
Station

20

19

Mersey Tunnel

Albert Dock

24

Birkenhead

River Mersey

LIVERPOOL LOCATIONS
SCENES 17-24

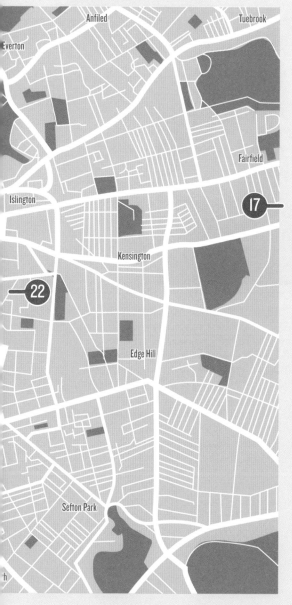

17.
NO SURRENDER (1985)
RAF Burtonwood, Warrington
page 52

18.
DREAMCHILD (1985)
Seacombe Ferry Terminal, Wallasey
page 54

19.
LETTER TO BREZHNEV (1985)
Albert Dock
page 56

20.
THE FRUIT MACHINE (1988)
The Fruit Exchange, Victoria Street,
(interior)
page 58

21.
DISTANT VOICES, STILL LIVES (1988)
The Futurist Cinema, Lime Street
page 60

22.
THE DRESSMAKER (1988)
Liverpool Cathedral, St James Mount
page 62

23.
SHIRLEY VALENTINE (1989)
St Pancras International Station,
Euston Road, London
page 64

24.
DANCIN' THRU THE DARK (1990)
The Krazyhouse, Wood Street
page 66

NO SURRENDER (1985)

RAF Burtonwood, Warrington

DESCRIBED BY WRITER Alan Bleasdale as a 'deadpan farce', *No Surrender* is a study in untrammelled prejudice. Everyone enjoying what the opening caption calls 'a normal night out (these days)' hates someone else, with the exception of Mike Moriarty (Michael Angelis), the new manager of the Charleston Club on Stanley Road – which was actually constructed by production designer Andrew Mollo in the cinema at RAF Burtonwood near Warrington, where James Stewart had been stationed as a B-24 bomber pilot and Humphrey Bogart, Bob Hope and Bing Crosby had entertained the troops. As New Year's Eve progresses, Mike will witness sectarian bigotry, homophobia, gerontophobia and gangland thuggery, while also being the victim of some casual racism on account of his Greek ancestry. Even his allies on the staff are prone to intolerance, with ex-Foreign Legionnaire bouncer Bernard (Bernard Hill) loathing gay comic Frankie Diamond (Peter Price) and kitchen helper-cum-aspiring singer Cheryl (Joanne Whalley) having no time for either Protestants or the elderly. Yet, when it comes to discrimination, none can match the Orange Lodgers from the 12 July Memorial Hall and the fancy dress-wearing `pensioners' piss-up' from St Columba's Roman Catholic Social Club, who disembark from their coaches and barrack each other across the car park before blind boxer Paddy Burke (James Ellis) calls out his Loyalist counterpart Billy McCracken (Ray McAnally) to suggest they forget about Auld Lang Syne and settle old scores here and now. Mike manages to bundle them all inside, but his boast that `every hour's happy here' sounds more than a little hollow. ⇢ ***David Parkinson***

Photo © Paul Leather

Directed by Peter Smith
Scene description: Geriatric Catholic and Protestant coach parties square up outside a nightclub
Timecode for scene: 0:36:44 – 0:41:44

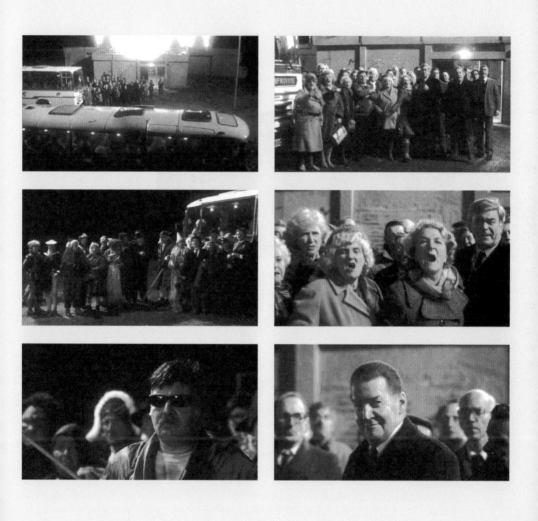

DREAMCHILD (1985)

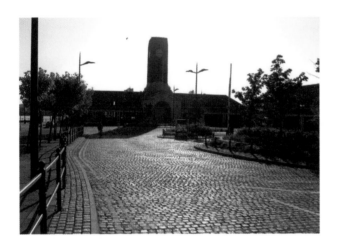

DREAMCHILD IS BASED UPON the 1932 voyage to America of 79-year-old Alice Liddell Hargreaves (Coral Browne), Lewis Carroll's child muse for whom he wrote *Alice in Wonderland*. On the occasion of Carroll's centennial, Columbia University bestowed an Honorary Doctorate upon Mrs Hargreaves. *Dreamchild* alternates between New York City during the Great Depression and flashbacks to the young Alice's (Amelia Shankley) childhood encounters with Reverend Charles Dodgson, aka Carroll (Ian Holm). The arrival by boat of Mrs Hargreaves in Manhattan becomes a media event. Bearing welcome signs and a stuffed bunny rabbit, reporters assail her, paparazzi-style, hailing her as 'better than Huck Finn, Peter Pan, and Santa'. The liminal space of the ship, at the threshold of Gotham City, is a site in which old and new values clash; to her surprise, journalists call her 'Alice' since '*Mrs Hargreaves in Wonderland* ... ain't got the same ring'. Alice/Mrs Hargreaves upholds her Victorian upbringing, instructing American children in rigid rules of etiquette. This scene, which supposedly occurred in Manhattan at the Cunard Line Pier 54, was in fact filmed at Wallasey's Seacombe Ferry Terminal, across the River Mersey from Liverpool. To a world beset by economic troubles, Alice – 'the little girl to whom Carroll once told his tales' – symbolizes a hopeful return to the Baudelairean 'green paradise of childhood'. She moreover evokes Gerard de Nerval, for whom 'le rêve est une autre vie' / 'dreams are another life'. Therefore Alice remains inscribed as a cultural icon, eternally ensconced within the popular imagination as Lewis Carroll's 'dream child'.
⊷ Marcelline Block

Directed by Gavin Millar
Scene description: Alice in Wonderland's arrival in New York City
Timecode for scene: 0:16:17 – 0:22:03

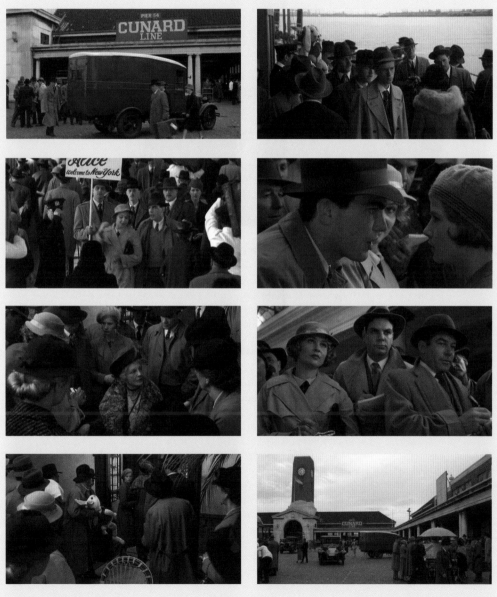

Images © 1985 PfH Ltd, Thorn EMI

LETTER TO BREZHNEV (1985)

Albert Dock

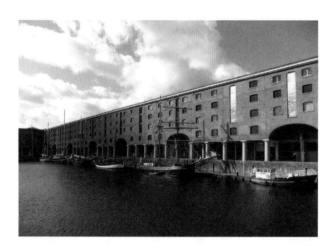

'WHY COULDN'T I JUST HAVE GOT INTO SOMEONE FROM KIRKBY?'
Elaine asks Peter as they share a final kiss through the diamonds of the wire fence at Albert Dock. Elaine, an unemployed, working-class girl has fallen in love with Peter, a Russian sailor on 24-hour leave in Liverpool. Their farewell galvanizes Elaine into recasting her own future and leads her to defy convention. Elaine realizes that her own personal growth could potentially be greater than any romance she'll find in Russia. The use of Albert Dock as the setting for their farewell compounds the understanding of Elaine's transformation. Symbolic of Liverpool's mercantile history, the dock is also synonymous with the social and economic problems that faced the city during the 1970s and 1980s. The prosperity of Liverpool had long been tied to its docks and for well over a century, Albert Dock had opened the city up to the wealth of empire. Built as the world's first non-combustible warehouse system, the dock used hydraulics to ease loading and unloading. Its failure however, to adapt to containerization led to a decline in shipping and the dock closed in 1971. Elaine follows Peter beyond the Iron Curtain because from that moment at Albert Dock her past experience becomes incompatible with the fresh potential of her future. Similarly, the future of Albert Dock became incompatible with its own history and it too was forced to redefine its identity; being redeveloped and then re-opened in 1988 as a tourist attraction.
➳ Susan James

Photo © Paul Cartwright

Directed by Chris Bernard
Scene description: Elaine and Peter share a final kiss at Albert Dock
Timecode for scene: 0:51:44 – 0:52:54

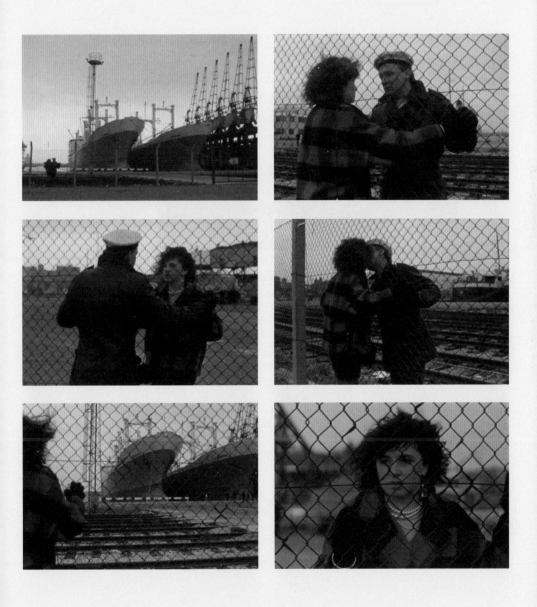

Images © 1985 Channel Four Films

THE FRUIT MACHINE (1988)

LOCATION *The Fruit Exchange, Victoria Street (interior)*

EDDIE (EMILE CHARLES) AND MICHAEL (TONY FORSYTH), both gay but otherwise complete opposites, are two teenage friends on the cusp of adulthood. The early scenes of *The Fruit Machine* show them on a night of sheer escapism as they try to leave behind their disparate backgrounds. Eddie is bullied by his father and over-indulged by his delusional mother who wraps him in the world of Hollywood glamour, the cinema being her escape from the harsh realities of her daily life. Michael's world is one of slot machines, saunas and the street where he hustles his way through life. The two stumble into a surreal transvestite nightclub called the Fruit Machine, run by Annabelle (Robbie Coltrane). Here the two embrace a different world and lap up the strange delights and sights of the underground, a world of glamour and damage. Michael daringly takes part in a dance-off competition resulting in a striptease and it is here that we see the adoration and high regard his friend Eddie has for him. It is a scene of sexual awakening and one that bonds the two. The early club scenes shot in Liverpool used an exterior located in Rainford Gardens but the interior we see is that of the Fruit Exchange nightclub on Victoria Street, a building dating from 1888 that was originally constructed as a railway goods depot and then converted into a fruit exchange in 1923 with an unusual heptagonal central hall by the architect J. B. Hutchins. ↦*John Maguire*

Photo © Paul Cartwright

Directed by Philip Saville

Scene description: Eddie and Michael enter the Fruit Machine Nightclub, they are both underage in this overtly underground Gay Nightclub
Timecode for scene: 0:31:33 – 0:32:40

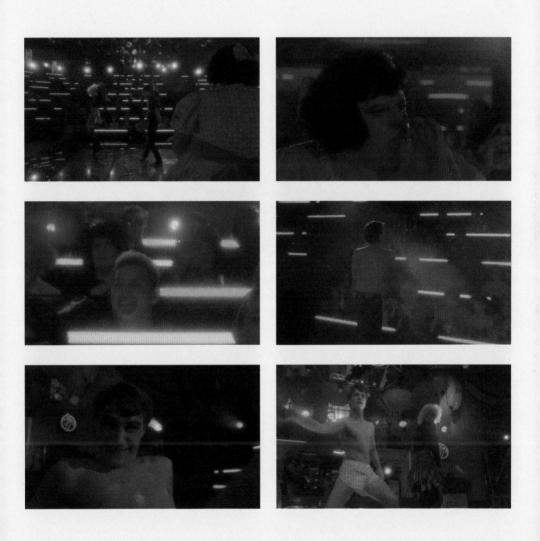

DISTANT VOICES, STILL LIVES (1988)

LOCATION *The Futurist Cinema, Lime Street*

IF TERENCE DAVIES LAMENTS one thing it is the loss of communal experience in a fragmented and individualistic age. The brief scene which takes place in the Futurist Cinema evokes a time when people still dressed up to go to the cinema, to watch Hollywood romances through a haze of cigarette smoke and tears. As the sisters, Eileen (Angela Walsh) and Maisie (Lorraine Ashbourne), weep at a screening of *Love is a Many-Splendored Thing*, a terrible accident befalls their brother and Maisie's husband. The sisters are bathed in the light of the cinema screen and their tears are a cathartic release in an era when suppression of emotion made the collective experience of cinema all the more powerful. The almost blissfully unrestrained weeping contrasts with quieter tears that are shed at other times in the film. Oscar Wilde wrote of sentimentality that it was a desire for the luxury of a feeling without having earned it. Terence Davies is a film-maker who portrays the Liverpool of his childhood through beautifully lit and composed tableaux. The use of music and his visual lyricism is evocative and emotionally charged. Yet sentimentality is not an accusation that would stick to this film-maker. Every emotion the characters feel is sincerely earned; none more so than the two women sharing their tears in the auditorium. The Futurist was an upmarket cinema on Liverpool's Lime Street that opened in 1912, and closed in 1982. Today it stands derelict, the opulent interior gone to ruin and the impressive Edwardian facade now crumbling. ➵***David Owain Bates***

Directed by Terence Davies
Scene description: Tears at the Futurist
Timecode for scene: 1:07:44 – 1:08:57

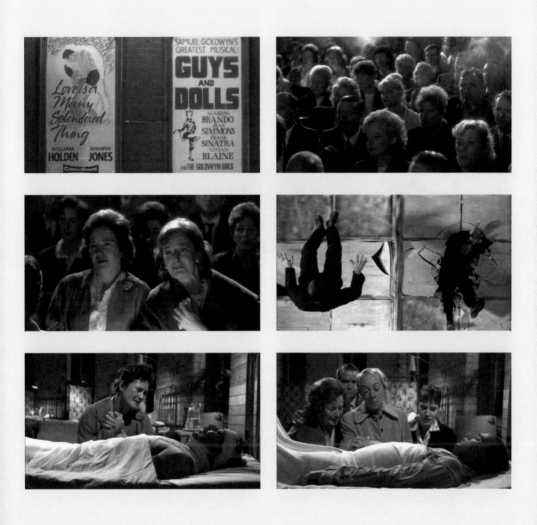

THE DRESSMAKER (1988)

Liverpool Cathedral, St James Mount

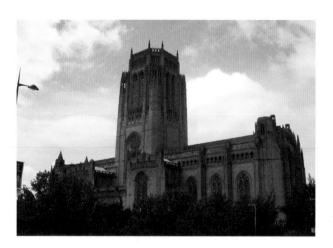

THE DARK INTERIORS of wartime Liverpool, both domestic and public, create a fitting landscape for this grim tale of lost love and sexual jealousy, based on Beryl Bainbridge's novel. Chaste dressmaker Nellie (Joan Plowright) leads a respectable life caring for her widowed sister Margo (Billie Whitelaw) and their motherless niece Rita (Jane Horrocks). Tensions between the three women erupt when 17-year-old Rita seeks the attentions of an American GI who is more attracted by Margo's flirtatious sexuality than Rita's shy charms. Upset by Wesley's rejection of her and with no understanding of why Nellie is disgusted by Margo's shameless display of wanton behaviour, Rita turns to the flamboyant Margo for advice on how to stimulate the GI's waning interest in her. Conflict between the two sisters comes to a head during a trip to the city's Anglican Cathedral. While Rita wanders inside to seek divine guidance, her small frame dwarfed by the towering architecture, Margo and Nellie rake over their simmering resentments in an impassioned argument outside. Begun in 1903 to a design by Giles Gilbert Scott and not completed until 1978, the sheer scale of the largest cathedral in Britain, with its 331 foot tower bearing down on the emotional scene beneath, emphasizes the oppressive power of religion in the city and how it has permeated peoples' lives. At the height of the Blitz in 1941, the unfinished building was consecrated as a sign of hope in the future. For the women, the prospects are less optimistic; unleashing long buried passions has tragic consequences. **Julia Hallam**

Directed by Jim O'Brien

Scene description: Rita prays in the cathedral while her aunts argue outside
Timecode for scene: 0:46:31 – 0:49:16

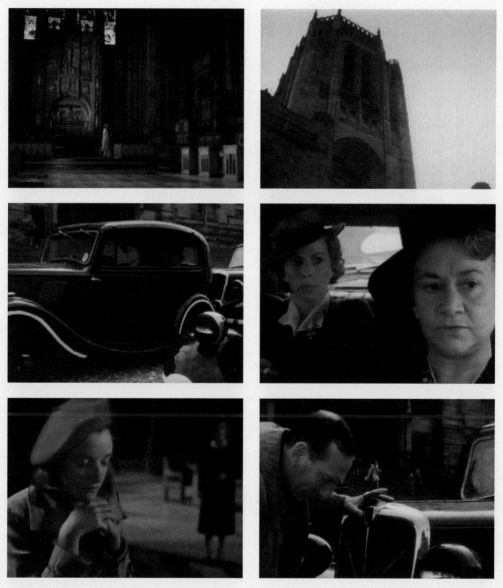

SHIRLEY VALENTINE (1989)

LOCATION *St Pancras International Station, Euston Road, London*

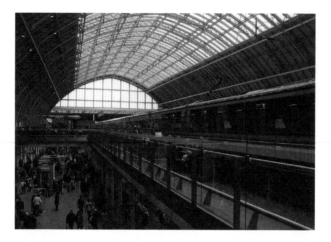

THE SCENE IN *SHIRLEY VALENTINE* where Shirley (Pauline Collins), encouraged by her friend Jane (Alison Steadman), enters a photo booth at Liverpool Lime Street Station encapsulates the mixed emotions that often surround critical points of departure. Shirley's feelings are echoed by the toing and froing of the passengers passing by the booth, feelings that 'ladies of a certain age' know only too well after putting their careers on hold in order to raise their children. Shirley's to-camera monologue in the booth, like all of those in the film, capture the thoughts of women perhaps never articulated previously, and the station setting serves as a place to think about directions in life beyond the present. The scene was actually filmed at St Pancras Station in London (an echo of the station scenes in *A Hard Day's Night* where Marylebone dubbed for Lime Street) and with its Victorian backdrop the viewer may align the image of the glass and metal station roof with the Eiffel Tower or Crystal Palace and an era now gone, when the exotic and the capacity to travel were new. This scene, like so many in Lewis Gilbert's screen version of the Willy Russell one-character play, is replete with great dialogue. Like a cacophonous echo resounding around the cavernous station interior, one can almost hear the collective voice of many a Scouse woman, as Shirley enters the photo booth, entreating, 'Come on Shirley love! The time has come to stop thinking and go on yer personal journey.' ➡ *Linda Jones*

Photo © Richard Symonds

Directed by Lewis Gilbert
Scene description: *Shirley enters the photo booth at Liverpool Lime Street Station*
Timecode for scene: *0:19:11 – 0:20:58*

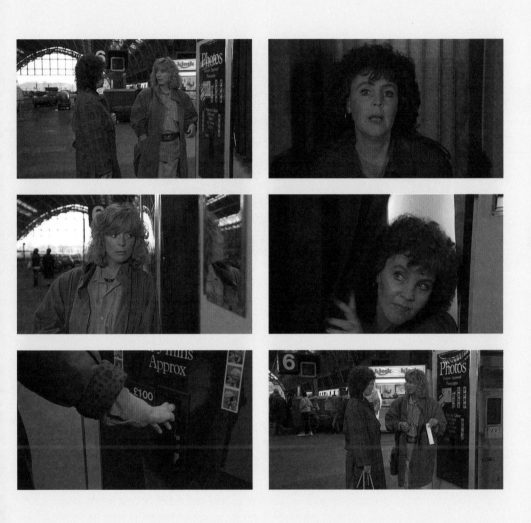

DANCIN' THRU THE DARK (1990)

The Krazyhouse, Wood Street

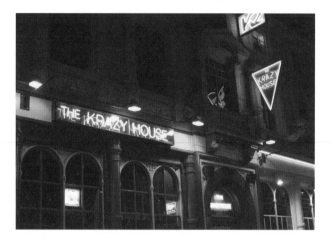

A RECENT POLL run by the redoubtable TripAdvisor put Liverpool at the top of the list of best British nightlife destinations. Much of this is owed to the city's rich musical heritage, although the scene has never rested on its laurels and down the decades the various venues have adapted and thrived. Written by Willy Russell, based on his play *Stags and Hens, Dancin' Thru the Dark* sheds light on Liverpool's nightlife of the 1980s through its depiction of the neon-lit pre-wedding 'last night of freedom' celebrations of Linda (Claire Hackett), out on the town with her gaggle of girlfriends while her fiancé is simultaneously on his stag night with his misfit mates. Linda is having reservations about entering into the marriage and her doubts reach a critical point when both groups end up at the same nightclub. As the evening gets underway, before the coming together of the groups, the girls muster in the ladies loo – somewhere they return to often to play out key scenes throughout the film – to powder their noses, smoke a ciggie and catch up on the gossip. Then it's out onto the dance floor for a group hoof around the handbags. The nightclub used in the film, referred to as Bransky's, is in fact the Krazyhouse on Wood Street, or the 'Kray' as it is widely known, a popular venue located in the heart of Liverpool's city centre that boasts three different dance floors and is one of the most established and diverse nightclubs in the city. **John Maguire**

Directed by Mike Ockrent
Scene description: The traditional hen night dance around the handbags
Timecode for scene: 0:31:49 – 0:32:25

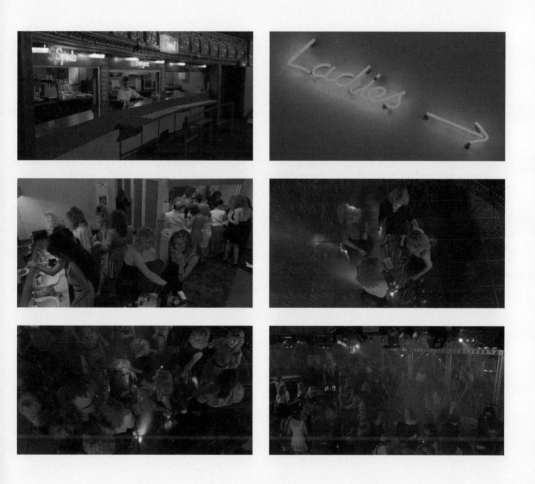

PLAY ROUGH

Text by
JACQUI
MILLER

*The Post-War Liverpools of the Magnet,
the Clouded Yellow and Violent Playground*

ALTHOUGH LOCATION SHOOTING is most often associated with the British New Wave of the late 1950s and early 1960s, the practice has a long tradition in British cinema. Three very different films – although each involving real or imagined crime – *The Magnet* (Charles Frend, 1950), *The Clouded Yellow* (Ralph Davis, 1950) and *Violent Playground* (Basil Dearden, 1958) utilize post-World War II authentic Liverpool locations to heighten narrative meaning and in so doing, present oppositional constructions of place and the sense of a liminal city, shifting like its river.

The Magnet has two sets of Liverpool settings and is a treasure trove for the local cultural historian. Its young protagonist, Johnny Brent (James Fox) is a middle-class psychiatrist's son who lived in what is now the depressed seaside (or rather estuary) resort of New Brighton on the Wirral Peninsula in the then heyday of British holiday-making when it truly was New Brighton. The beauty pageant at the waterfront pavilion, the vibrant funfair, and the nannies walking their charges on the beach present a counterpoint to Liverpool's usual grimy film and media image. It is also a fascinating revelation of a locale's

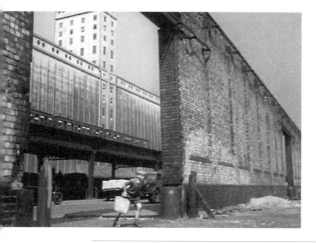

changing fortunes that Johnny boards at private school in Kirkby, then a rural oasis, now most associated with a run-down housing estate and the basis for television drama *Z-Cars*'s Newtown. Johnny believes he is being pursued by the police and flees to Liverpool city centre. Crossing the River Mersey by ferry or going 'over the water' as the locals say, and falling in with a gang of slum-kids gives an opportunity to show the city/suburb contrasts, but also spaces of possibility. Liverpool was heavily bombed during World War II, and in 1950 was barely re-built. The bombsites around the landmark Anglican cathedral where Johnny meets the gang are tabulae rasae, not only allowing for new beginnings, but also a merging of class and identities; the 'scallies' and Johnny band together in a way that would be impossible in rigidly stratified New Brighton. This can be seen too with regard to ethnicity. As a melting pot port city, Liverpool has the world's oldest Chinatown and in one stand-out scene a Chinese-Liverpool boy speaks Scouse to his friends whilst simultaneously conducting a conversation with his mother in Mandarin.

Chinatown, with its proximity to the undefined spaces of the bombsites, is also a key location in *The Clouded Yellow*, a film that is at first glance a 'stiff-upper-lip' thriller, but made much more complex by the effect of settings. A former secret service agent, Major David Somers (Trevor Howard) goes on the run with Sophie (Jean Simmons), a troubled young woman suspected of murder, crossing the country from Hampshire to Newcastle, the Lake District and eventually Liverpool. Chinatown is closely detailed, including interiors of a restaurant and a lodging house. It is portrayed as exotic, not in the sense of 'other' but as a place where the rigidities of identity may break down. Just as class and ethnicity were slippery in *The Magnet*, in *The Clouded Yellow* gender boundaries are transgressed as Sophie, in garments bought from a seedy second-hand store and with hair cropped, assumes the persona of a young man to effect her escape.

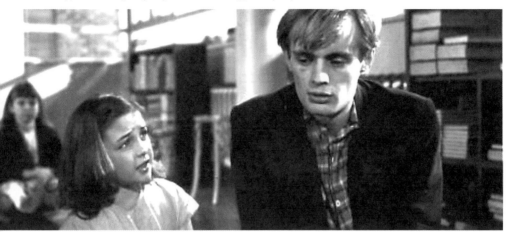

Violent Playground is a British contribution to the juvenile delinquent genre. Whereas *The Magnet* and *The Clouded Yellow* use locations – the river, the bomb sites, Chinatown – to present a Liverpool of liminalities, *Violent Playground* uses its panoply of landmark sites to hammer home its message that the city is a breeding ground of crime for deprived youngsters.

From the start it melds the twin dangers of the urban environment and Liverpool's edgy reputation as a rock 'n' roll city. A panorama of locations finally settles on a sprawling concrete estate on which 'Violent Playground' is superimposed as the soundtrack has Johnny Luck singing 'I'm gonna play rough, rough, rough, I'm gonna play tough, tough, tough'. Rock 'n' roll continues as a deviant thread throughout: a gun is concealed in a guitar case and a gang of juvenile delinquents dance menacingly and undeniably homoerotically, encircling the Juvenile Liaison Officer (Stanley Baker).

The narrative begins as a swarm of children play on a concrete playground; a precursor to the violent city playground of their implied future. The playground is surrounded by railings, and throughout, locations are used to create a sense of the imprisonment that will follow from delinquency. Its principal setting is a notorious social housing estate, with the ironic name of Gerard Gardens (it is the antithesis of New Brighton's leafy thoroughfares),

> **From the start it melds the twin dangers of the urban environment and Liverpool's edgy reputation as a rock 'n' roll city.**

its tenements surrounded by high walls. Known colloquially as the bullring (part of which survives as current student accommodation), this term connotes claustrophobia and entrapment. Many scenes are of interiors: a cramped flat, the police station, a hotel service area, a gloomy, foreboding church, and a long classroom siege.

Tracking a teenage arsonist, Johnny Murphy/ The Firefly (David McCallum), *Violent Playground* moves outside and roams across the city, but the exterior world seems to close in even tighter. As Johnny drives around, everywhere high buildings loom and police cars circle in. There are two ways of crossing the Mersey: 'over the water' or under, through one of the two Mersey tunnels. Whereas the protagonists of *The Magnet* and *The Clouded Yellow* arrive by boat, foreshadowing the freedoms the city will bring, in *Violent Playground* we do not go over, but under the river, entering the Queensway/Birkenhead tunnel. Even this method of escape is ambiguous; Johnny does not go through the tunnel but doubles back, back into the imprisoning city. In a further contrast of locations, one of Liverpool's most fondly remembered bygone landmarks, the dock-front elevated railway, is travelled by Johnny Brent and David Sommers, but Johnny Murphy meets an accomplice under the now defunct 'el' to be given a gun; the station used in *Violent Playground* is Liverpool Central, part of the underground network.

Although subsequent films continued to use Liverpool settings, arguably none have harnessed iconographic buildings and locations to distil the atmosphere and sense of Liverpool's multifacets as did the post-war productions. ✢

LIVERPOOL

maps are only to be taken as approximates

N

LOCATIONS MAP

29 Wallasey

30 Salisbury Dock

Kingsway

Princes Dock

Vauxhall

27

28

Lime Street Station

32

Mersey Tunnel

Albert Dock

Birkenhead

River Mersey

LIVERPOOL LOCATIONS
SCENES 25-32

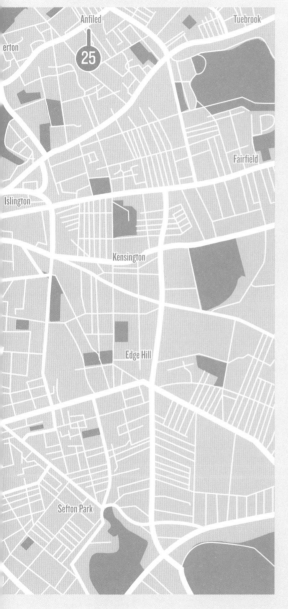

25.
THE MAN FROM THE PRU (1990)
Wolverton Street, Anfield
page 72

26.
THE LONG DAY CLOSES (1992)
Hackney Empire, London (balcony interior)
page 74

27.
IN THE NAME OF THE FATHER (1993)
Brunswick Vaults, Tithebarn Street
page 76

28.
BACKBEAT (1994)
Hessy's Music Centre, the corner of Stanley
Street and Whitechapel, Liverpool City
Centre (closed in 1995)
page 78

29.
BLOOD ON THE DOLE (1994)
Grange Hill War Memorial,
West Kirby, Wirral
page 80

30.
PRIEST (1994)
Crosby Beach, Blundellsands
page 82

31.
AN AWFULLY BIG ADVENTURE (1995)
Bewley's Oriental Café, Grafton Street,
Dublin 2, Ireland
page 84

32.
PEGGY SU! (1997)
Liverpool Town Hall, High Street, Chamber
page 86

THE MAN FROM THE PRU (1990)

LOCATION *Wolverton Street, Anfield*

29 WOLVERTON STREET has never acquired the notoriety of 10 Rillington Place, but this terraced house in Anfield was the scene of a brutal crime that remains unsolved. On 20 January 1931, Julia Wallace was fatally bludgeoned in her front parlour. This occurred while her husband William was busy searching for a non-existent address after receiving a telephone message requesting a 7.30 p.m. appointment to discuss an insurance policy with the Prudential Assurance Society, for whom Wallace was a collections agent. A key piece of the dourly taciturn suspect's alibi was that he caught a tram on Smithdown Lane at 7.06 p.m. As milk boy Alan Close insisted he spoke to Julia around 6.45 p.m., Detective Superintendent Hubert Moore decided to see if Wallace could have killed his spouse and still reached the stop in time. In Rob Roher's Screen Two reconstruction, Detective Sergeant Harry Bailey (Geoffrey Hughes) leaves through No.29's back gate and hurries along several serpentine alleyways – being teased en route by idling scallywags and hampered by various pedestrians and a coalman – before checking his stopwatch to surmise that Wallace (Jonathan Pryce), a 52-year-old smoker in poor health, could almost certainly not have made such a dash in the allotted time. In fact, nine different test runs were performed and the film has Bailey coerce Close (Simon McLeod) into changing his story to fit the police thesis. Such flaws in the circumstantial evidence led Wallace to become the first Briton to have his murder conviction quashed on appeal. ➻ **David Parkinson**

Photo © Ged Fagan

Directed by Rob Rohrer
Scene description: A policeman re-enacts a murder suspect's dash for a tram
Timecode for scene: 0:44:19 – 0:44:57

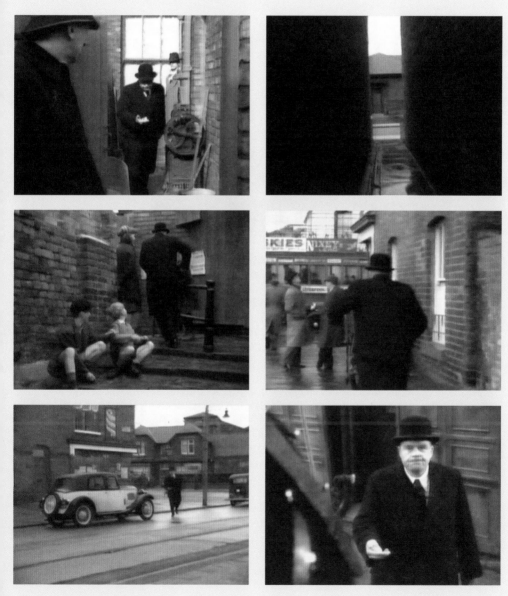

THE LONG DAY CLOSES (1992)

LOCATION *Hackney Empire, London (balcony interior)*

IN ONE OF THE INNUMERABLE slow tracking shot sequences in *The Long Day Closes,* Terence Davies's second autobiographical feature length film about his Liverpool childhood (after *Distant Voices, Still Lives* [1988]), he uses the Carousel Waltz from Rogers and Hammerstein's *Carousel* to link together a scene of 11-year-old Bud (Lee McCormack) feeling alone and isolated at his school desk with subsequent scenes in which he bathes in the warmth, light and love of his family members, first at the cinema, then at the funfair. The backlit Bud at school dreams of the contrasting pleasure of a night out at the pictures, and initially the music seems imagined. When we dissolve and pan along the ornate cinema balcony (with precious few suitable location options in his home city Davies used the plush red velvet and gilded plasterwork of the Hackney Empire as a summation of his lovingly remembered Liverpool picturehouse interiors) we see Bud backlit again, this time by the bright flicker of the projector, and it's our turn to imagine. The music is now the soundtrack to the movie he is watching and as the shot momentarily rests on the rapt cinemagoers we are left to picture the Technicolor Cinemascope splendour of the 1956 film version of *Carousel* in our mind's eye. The shot descends and fades into the smoky darkness of the auditorium and the lights that emerge are those of a Ferris wheel at a New Brighton of the cinematic imagination through which Bud walks, a place appropriately complete with Waltzers spinning in time to the Richard Rogers melody. ➻*Jez Conolly*

Directed by Terence Davies
Scene description: Bud rides the carousel of school, cinema and funfair
Timecode for scene: 0:15:03 – 0:16:25

IN THE NAME OF THE FATHER (1993)

LOCATION *Brunswick Vaults, Tithebarn Street*

THE POWERFUL OPENING SEQUENCE of Jim Sheridan's *In The Name of the Father*, adapted by Sheridan and Terry George from Gerry Conlon's autobiography *Proved Innocent: The Story of Gerry Conlon of the Guildford Four*, serves to illustrate the arbitrary outcomes of terrorism, for the victims and by extension for those wrongly accused of perpetrating the acts. The scene depicts the IRA bombing of the Horse and Groom pub in Guildford at 8.30 p.m. on 5 October 1974; the opening credits, interwoven with a drum-heavy piece of music by Bono and Gavin Friday, appear interspersed between shots of happy pub revellers on an evening out. Within moments of their entry into the warm, welcoming interior of the pub the screen is violently lit up by the detonation of the secreted explosive device, causing smoke, flames and debris to spill out onto the street. A solemn darkness descends, shrouding both death and guilt, a darkness that we see pursued by the attorney Gareth Peirce (Emma Thompson) in the first post-credits scene as she drives into a tunnel – the mouth of the Mersey Tunnel is put to use here – at the beginning of her involvement in the case. Several Liverpool locations were used as stand-ins during the film. The opening bomb blast scene was actually shot at a carefully mocked-up Brunswick Vaults on Tithebarn Street, a pub at the heart of what is now the city's business district. The Brunswick has been more recently converted into a gastropub and renamed the James Monro.
⇝ John Maguire

Directed by Jim Sheridan
Scene description: The bombing of the Horse and Groom
Timecode for scene: 0:00:00 – 0:02:58

BACKBEAT (1994)

Hessy's Music Centre, the corner of Stanley Street and Whitechapel, Liverpool City Centre (closed in 1995)

BACKBEAT NARRATES THE LAST YEARS in the life of the 'fifth Beatle', bass player Stuart Sutcliffe, who tragically died of a brain haemorrhage in 1962 at the age of 21. In paying homage to the early Beatles, *Backbeat's* director/co-writer Iain Softley attempted to recuperate the memory of those involved with the band from its earliest days onwards, and who form, in Softley's words, more 'than the footnote in somebody else's story'. Central to *Backbeat* is the friendship between John Lennon (Ian Hart) and Sutcliffe (Stephen Dorff), who met at Liverpool College of Art. As The Beatles rose in popularity in Hamburg, when playing clubs such as the Kaiserkeller, Sutcliffe realized he would rather leave the band and pursue a career as a painter in Hamburg's bohemian art scene. He had also fallen passionately in love with photographer Astrid Kirchherr (Sheryl Lee), who took some of the most iconic pictures of The Beatles during this period and even inspired their signature hairdo. This early *Backbeat* scene features lighthearted banter between Lennon and Sutcliffe. They debate the merits of different guitars displayed in the window of Hessy's Music Centre on Stanley Street. Originally owned by Frank Hesselberg, Hessy's was beloved by local musicians for, among other reasons, its generous credit policy. Hessy's appears briefly in the film, long enough for Beatles enthusiasts to recognize it as the store where John Lennon's bought his first guitar. A longtime Liverpool landmark and tourist site, Hessy's closed down in 1995 after 60 years in business, yet lives on in Beatles lore. **⇢Marcelline Block**

Photo © Paul Cartwright

Directed by Iain Softley
Scene description: Where it all began
Timecode for scene: 0:08:15 – 0:08:27

BLOOD ON THE DOLE (1994)

LOCATION *Grange Hill War Memorial, West Kirby, Wirral*

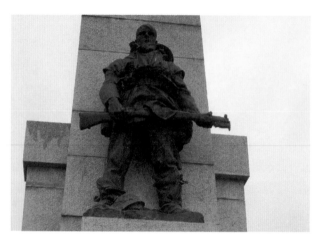

IT'S EVIDENT FROM THE MOMENT school-leavers Joey Jackson (Stephen Walters) and Ricky Jones (Philip Dowd) first pass the Grange Hill War Memorial in West Kirby and consider the concept of the Unknown Soldier that this entry in Channel 4's *Alan Bleasdale Presents* series of telefilms equates those who gave their lives in the service of their country with those being sacrificed by the Conservative government in its battle against industrial inefficiency and union might. Joey alludes to the siege of Stalingrad as he tells Ricky they have to remain active rather than surrender to the depressing realities of unemployment, and a trip to the Walker Art Gallery in Liverpool reinforces the conceit when Ricky is moved by the sculpture of a warrior in his death throes. Even when the pair enter a nightclub intent on conquering former classmates Cathy (Suzanne Maddock) and Jean (Rachel Caldwell), Joey quotes Tennyson's poem 'The Charge of the Light Brigade' and his brawl with teacher David Williams (Aneirin Hughes), who has been dating Cathy, proves just as inglorious. Thus, it comes as no surprise when Ricky runs out of options and joins the army, only to be killed on his first tour of active duty in Northern Ireland. Adapting from his own stage play, Jim Morris has Joey grim-facedly carve Ricky's name into the memorial stone and stand beside Cathy to sing B. F. White's lament 'The Lone Pilgrim' (which had just been recorded by Bob Dylan), so that at least one member of this new lost generation would never be unknown. **↠ David Parkinson**

Directed by Pip Broughton
Scene description: A teenager carves his fallen friend's name on a war memorial
Timecode for scene: 1:27:48 – 1:30:19

PRIEST (1994)

Crosby Beach, Blundellsands

LINUS ROACHE STARS in Antonia Bird's *Priest* – a drama of a man torn. The conservative Catholic Father Greg Pilkington arrives at a North Liverpool parish to 'do his part for the inner-city' and is quick to demonstrate his devotion against the questionable faith of some of his new colleagues. We soon learn Greg is conflicted, however, as he attempts to reconcile the Sacrament of Penance with the suffering of a parishioner, and his homosexuality with his beliefs. In this scene, Greg picnics and takes a stroll with his lover, Graham (Robert Carlyle) on Crosby Beach in Blundellsands. Looking out upon the Irish Sea, he speaks of martyrdom and certainty of God, and how the dangers of evil are quick to dispel his faith. Keeping their relationship a secret, they are first moved on by a child who tries to steal their coffee, jesting that their refusal 'isn't very Christian' before chasing the seagulls. The scene culminates with a passionate kiss between lovers, instigated by Greg and shot at eye-level in a sweeping circular motion. The scene today would be populated by Antony Gormley's modern sculpture *Another Place* – iron figures of men staring west, out to sea. Models of unwithering certainty and faith, they become submerged at night as the landscape changes around them. This submersion and rebirth echoes sins forgiven and cleansed in Church, as the secret kiss in plain sight on an open coastline demonstrates sins opened to the world. Crosby Beach becomes a sacred place where certainty, if not faith, seems found. •➤**Nicola Balkind**

Photo © Paul Cartwright

Directed by Antonia Bird
Scene description: Father Greg Pilkington and his lover picnic on Crosby Beach
Timecode for scene: 0:46:00 – 0:48:13

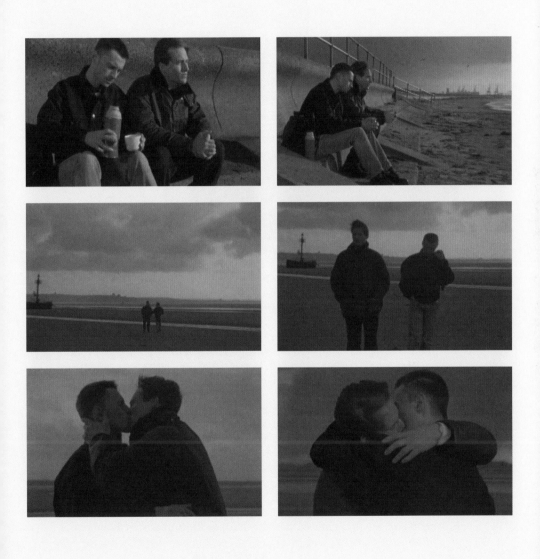

AN AWFULLY BIG ADVENTURE (1995)

LOCATION *Bewley's Oriental Café, Grafton Street, Dublin 2, Ireland*

SET IN POST-WORLD WAR II LIVERPOOL, the principal photography for Newell's film was shot in central Dublin, featuring many of the iconic locations familiar to that fair city's population, such as Bewley's Oriental Café, the Olympia Theatre and the docks area, which readily lend themselves to a believable visual representation of 1920s Liverpool. Stella Bradshaw (Georgina Cates), the main character, is brought to a traditional cafe by the theatre company's director Meredith Potter (Hugh Grant) and stage manager Bunny (Peter Firth) as a form of audition. This is an amateur outfit with a bunch of misfits playing out various complications in their lives. The cafe features throughout the film as a place for crew and cast members to get together and share the gossip of life in the theatre, a place not unlike Bewley's Oriental Café on Grafton Street which has served as a Dublin institution since 1927, for many generations of writers, actors, directors, students and anyone who had time to while away. Always a welcoming spot, there was no time limit on how long you could spend over a cup of tea or coffee. While the cafe depicted in the film could easily be a Merseyside tea-room, the scenes resonate particularly for an Irish audience familiar with the institution of Bewley's. This scene carries with it a sense of verisimilitude, no doubt many an audition and theatre gossip shared in the establishment down through the decades, in real life and in fiction. ↠*Díóg O'Connell*

Photo © Jez Conolly

Directed by Mike Newell
Scene description: Stella 'auditions' for Meredith Potter and Bunny in a local cafe
Timecode for scene: 0:06:45 – 0:09:00

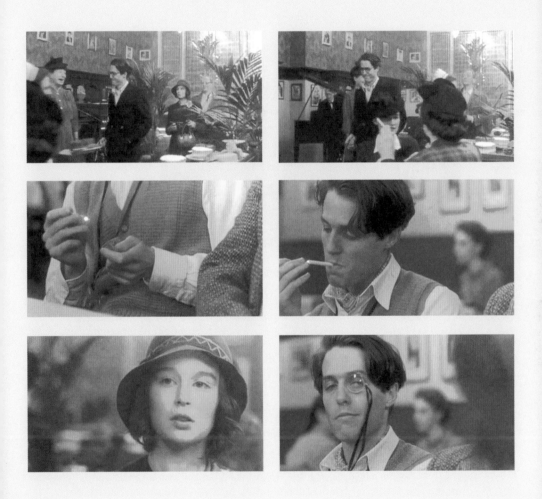

PEGGY SU! (1997)

Liverpool Town Hall, High Street, Chamber

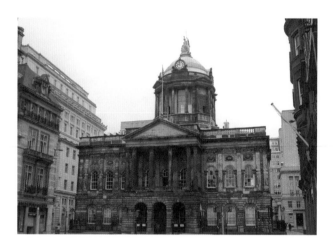

LIVERPOOL'S CHINATOWN in the early 1960s is the setting for this romantic comedy, written by Anglo-Chinese playwright Kevin Wong, drawing on his roots as the son of two Chinese émigrés who worked in the laundry business. At the start of her date with a potential suitor, the diminutive 19-year-old Peggy Su (Pamela Oei) enters the high-ceilinged Georgian grandeur of Liverpool Town Hall and nervously glances up the imposing staircase that will lead to the dining hall where she is due to meet smooth-talking restaurateur David (Glen Goei). At dinner Peggy feels uncomfortable with the formality of the setting; she asks the waiter for some soya sauce to have with her chips. David looks askance at this but quickly pastes on his charming smile, which fades again when Peggy gesticulates nervously with her knife, managing to accidentally flick a chip into a diner's drink. Frances-Anne Solomon's charming Austen-tinged tale of a plain girl in search of Mr Right uses the opulence of the dinner date setting to contrast with the busy confines of the Chinese laundry. Liverpool Town Hall was built between 1749 and 1754 to a design by John Wood the Elder, then restored by James Wyatt after a fire destroyed much of the building in 1795. The building had another lucky escape in 1881 when the Fenians attempted to blow it up. In more recent times the Beatles waved to their adoring fans from its front balcony. As seen in *Peggy Su!*, the Town Hall's mid-1990s restoration is shown off to great effect.
↝ Caroline Whelan

Photo © Paul Cartwright

Directed by Frances-Anne Solomon
Scene description: Peggy Su's dinner date at the town hall
Timecode for scene: 0:14:09 – 0:17:27

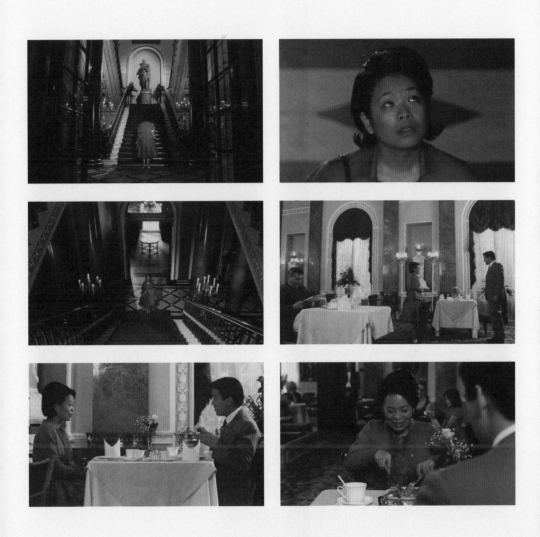

THE LAST OF LIVERPOOL

Text by
LES
ROBERTS

SPOTLIGHT

Liminal Journeys Around the Port City

DISPOSSESSION, unemployment, decline, urban insurrection, a Tory prime minister in Downing Street: the mise-en-scène of David Cameron's Britain folds seamlessly back into the cultural landscapes of a decade it both mirrors and abjures in equal measure, like a looped rerun of the nostalgia drama series *Ashes to Ashes*, or an Adam Ant (or Smiths) tribute band that has worn out its welcome. That the bittersweet Proustian returns of Terence Davies's *Of Time and the City* (2008) end in the 1970s, when the film-maker left behind the city of his birth for good, can only be looked upon as a blessing. Had he hung around until the 1980s, a period in which the city's post-war, post-industrial fortunes had slumped to their lowest ebb, the depths of his archival despair would have surely known no bounds. Caustic, poetic, iconoclastic, defiantly off-message; despite its elegiac tone and 1980s amnesia, Davies's film brings to mind the work of another gay independent film-maker who, like Davies, was no less a significant landmark in the British cinema of the 1980s.

Derek Jarman, whose *The Last of England* (1987) taps the psychogeographic frenzy of London's post-industrial docklands, wove his own brand of cinematic bricolage around an often abrasive lyricism that drew its potency in part from the entropic slipstream of deregulation and de-industrialization: two defining totems of post-Thatcherite political economy. With its memorably apocalyptic images of Tilda Swinton's Thames-side 'dervish dance', as Iain Sinclair described it in 2009, *The Last of England* is a film that many could be forgiven for thinking was shot solely in London, rather than, as was in fact the case, also in parts of an equally ravaged-looking Liverpool. Interestingly, though, it is not the River Mersey or the crumbling obsolescence of the dockside infrastructure that we glimpse but an otherwise non-place-specific housing estate located outside the city centre, beyond any obvious geographical markers and symbols that would anchor the viewer firmly within Liverpool. In this regard *The Last of England* is well in keeping with the vast majority of productions shot in Britain's second most filmed city in that the Liverpool locations featured in the film could just as well serve as a double for other places and times. Indeed, insofar as the Liverpool sequence showcases a residential landscape in a state of utter dereliction and decay, these images serve as a metonymic index of large swathes of urban Britain in the late 1980s as the impacts of unemployment and industrial decline began to leave their mark on working-class communities from Merseyside to Middlesbrough and beyond.

The Liverpool footage was shot not by Jarman but by the cinematographer Chris Hughes who drove around Merseyside locations with the Liverpool-born actor (and frequent Jarman collaborator) Spencer Leigh. Slow motion tracking shots filmed from a moving car, the grainy Super

Opposite © 1988 Anglo International Films / British Screen Productions

8 film stock awash with an apocalyptic miasma of red, a seemingly endless panorama of boarded-up houses, provides a terminally bleak counterpoint to the Lumière footage shot from the Liverpool Overhead Railway in 1897, the first ever moving images of what was then a rapidly modernizing industrial powerhouse. At the turn of the century the port city's geographically liminal status was matched by a temporal liminality that denoted its incipient modernity: a city 'on the move' in the sense of 'going places'. In the 1980s, by contrast, Liverpool found itself in what early anthropologist Arnold Van Gennep describes as a 'liminal phase' that marked a period of transition that might more accurately be described as a state of entropy: a city not 'on the move' but one suspended in the interstices of history and identity, waiting for some form of reincorporation into or consummation of a renewed historical trajectory. Shunting back and forth between states of mobility and stasis, by the 1980s Liverpool was a rapidly depopulating city where a sense of agency in movement was more likely to take the form of migrations out

The Last of England is well in keeping with the vast majority of productions shot in Britain's second most filmed city in that the Liverpool locations featured in the film could just as well serve as a double for other places and times.

of Merseyside (like Terence Davies, Spencer Leigh, and many, many others) in the hope of securing better prospects elsewhere.

Considered in this broader social context the scenes in *The Last of England* of refugees waiting on the quayside (in East London) for passage to a new life 'out there' beyond the finite horizons of everyday experience also gives symbolic expression to a narrative and structure of feeling that spoke powerfully of Liverpool as a city teetering 'on the edge' – in more ways than one – after years of decline. The film's title is a reference to the painting of the same name by the Pre-Raphaelite painter Ford Maddox Brown which depicts emigrants embarking for the New World. Again, a theme that has particularly strong resonance for the port city. The ebb and flow of Liverpool's human tide – whether the errant father in *Waterfront* (Michael Anderson, 1950) whose prolonged absence as a merchant sailor shapes a strong matriarchal family unit that is left to fend for itself in the waterfront slums of the 1930s; or the forced migration of children to Australia in the 1950s as dramatized in the BBC mini-series *The Leaving of Liverpool* (Michael Jenkins, 1992); the revolutionary journeys undertaken by Spanish Civil War volunteers in *Land and Freedom* (Ken Loach, 1995); or the Cold War 'cultural exchange' comedy *Letter to Brezhnev* (Chris Bernard, 1985) – has inscribed a cinematic and emotional cartography of poignant and contingent liminality. Rites of passage – social, sexual, geographic, political – are the structural threads that pull these otherwise disparate narratives together, shaping a sense of place that is firmly anchored because not despite of its constitutive liminality. Although it would be stretching things to reclaim Jarman's excoriating masterpiece as a 'Liverpool film', to the extent that it evokes a dormant spirit of anger and rebellion, and with it, the possibility of change or transition, *The Last of England* is no more a negation of England than a re-assertion of values and identities – and by implication the cultural spaces that make these possible – that have been discarded and trampled underfoot. In this respect the film speaks as much, or perhaps more, for Liverpool as for any English town or city; and, indeed, as much for now as for the not so dim and distant years of Thatcherism. To proclaim the 'Last of Liverpool' is not to mourn its passing but to imagine and embark on liminal journeys through landscapes where the scope and direction of change can be measured and thus more persuasively mapped. ✤

LIVERPOOL

maps are only to be taken as approximates

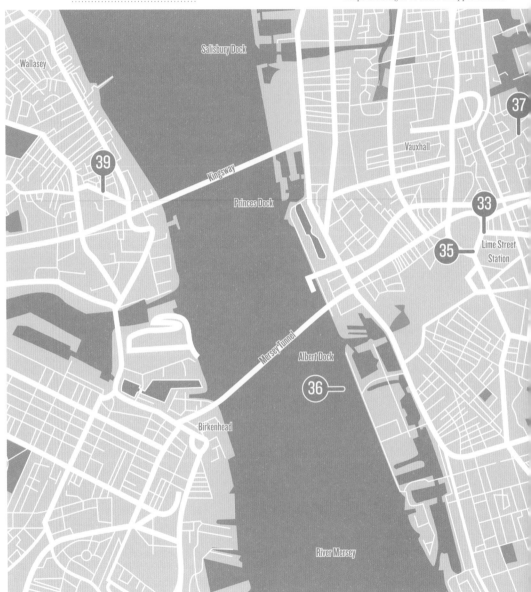

Salisbury Dock

Wallasey

37

Vauxhall

39

Kingsway

Princes Dock

33

35

Lime Street Station

Mersey Tunnel

Albert Dock

36

Birkenhead

River Mersey

LIVERPOOL LOCATIONS
SCENES 33-39

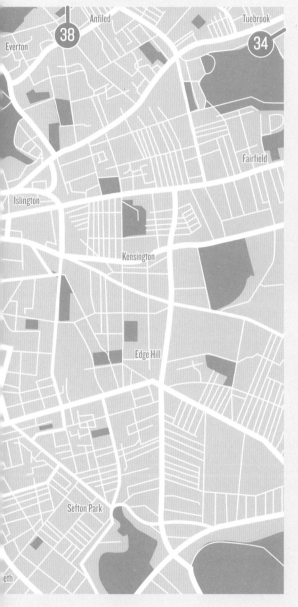

THREE BUSINESSMEN (1998)

Liverpool Lime Street Station & Adelphi Hotel

ALEX COX'S *Three Businessmen* is a British-Dutch-Japanese feature that traverses the globe in the course of one night. It is fitting, then, that Benny (Miguel Sandoval) arrives at Liverpool Lime Street train station in the characteristic English drizzle. Dragging two cases and a bag, he shuffles towards the first taxi he sees, pointing at a piece of paper – a map or hotel address, it is not clear – for the benefit of the taxi driver. When he hops in, however, he has little time to relax as the taxi screeches around the corner directly to his destination which, it transpires, is a neat 100 yards away. Perhaps Benny missed a memo as the Edwardian-style Adelphi Hotel, constructed in Portland stone, boasts of its location on Ranelagh Place: a mere 3-minute walk from Liverpool Lime Street station. The camera does not linger on its entranceway or columns, cutting directly to Benny's entrance to the foyer, but this little journey sets the film up nicely for its absurd tone. It also kicks off the protagonist's upcoming journey which, beginning with the search for a meal, ends up in an around-the-world trip through Rotterdam, Hong Kong and Tokyo. Upon entering the hotel's small but luxurious lobby, the bell-hop (played by that stalwart Scouse actor, Andrew Schofield) conspiratorially offers him a better room – one with a jacuzzi. Benny agrees before offering him a colloquial 'cheers, mate' and setting off with his cumbersome luggage to find his newly upgraded dwellings. **↦Nicola Balkind**

Photo © Paul Cartwright

Directed by Alex Cox
Scene description: Benny's short taxi ride from Liverpool Lime Street Station to the Adelphi Hotel
Timecode for scene: 0:02:48 – 0:05:17

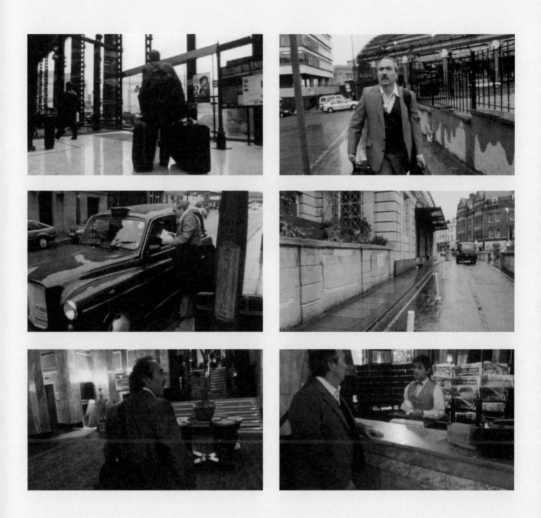

THE TICHBORNE CLAIMANT (1998)

LOCATION *Croxteth Hall & Country Park, Croxteth Hall Lane*

BASED ON REAL-LIFE EVENTS, *The Tichborne Claimant* recounts the tale of perhaps the greatest hoax of the nineteenth century. Savvy Afro-English manservant Bogle travels to Australia to observe a man claiming to be Roger Tichborne, one of the richest noblemen of England, believed lost years earlier in a South American shipwreck. Despite his own reservations regarding this crass, unsophisticated wino, Bogle returns to England with the claimant as well as his charlatan wife and children in tow. Conspiring to split the vast inheritance an heir to the Tichborne fortune would be owed, the two men work to convince a cagey aristocracy of the legitimacy of their claim. This farce is no more evident than when Roger visits Tichborne Park for what is, in all likelihood, his very first time. Here, history serves in the place of history as Croxteth Hall doubles for the Tichborne home (in actuality located east of Hampshire). Despite an overbearing roguishness and fondness for the drink, The Claimant wills the trust of the home's caretaker through sheer charisma. Traversing the staircase, he makes note of a table he observed in his youth still being in need of repair. It's a joking exchange – one offered only to further this prodigious ruse – but also a charming one. It's moments like these in the comedy that ingratiate the Claimant not only to his peers, but to the viewer as well. The vast openness of Croxteth Hall serves as a reminder of the stakes in which the conspirators partake. •*Tim Kelly*

Photo © Paul Cartwright

Directed by David Yates
Scene description: Roger's visit to Tichborne Park
Timecode for scene: 0:26:55 – 0:29:10

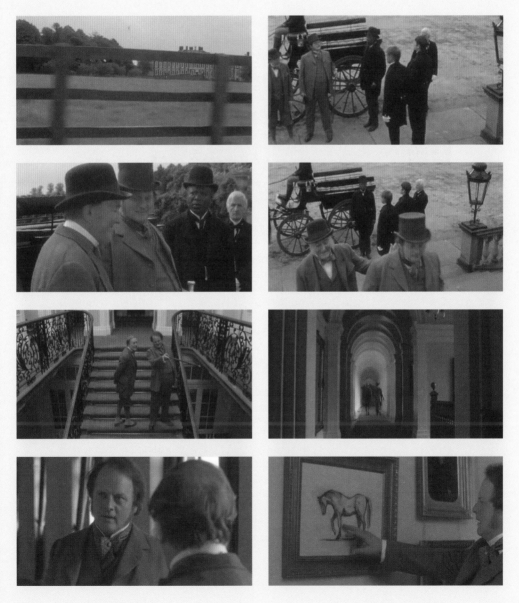

Images © 1998 Bigger Picture Company

HILARY AND JACKIE (1998)

LOCATION *The Concert Hall in St George's Hall, Lime Street*

HILARY AND JACKIE IS A TALE OF TWO SISTERS: musicians and best friends whose talents are pitted against each other by their parents. Flautist and cellist respectively, Hilary Du Pré's (Rachel Griffiths) celebrated talent is overtaken by the wilful ambition of her younger sibling Jackie (Emily Watson), whose rise to fame and struggles in musical high society are told from each sister's perspective. After a long separation, the sisters finally spend some time together, but Hilary awakes to find that Jackie has fled in the night. It transpires that she has been summoned for a concert in Germany – a concert which, in the context of the film, is set to be a climactic one. In this scene, Liverpool's neoclassical St George's Hall on Lime Street stands in for an unspecified Berlin concert hall. St George's is recognized as part of Liverpool's World Heritage Site status, lending the film a sense of European grandeur to match the music played within. The Concert Hall interior with its grand organ is the centrepiece of the scene. Jackie plays on a round podium, swathed in a red dress and bathed in the building's orange light. St George's organ, built by Henry Willis and completed in 1855, stands proud and resplendent on the stage behind. Even from a distance its ornate blue and gold decoration glistens, and when the camera spins to capture the hall's many golden columns and carved statues we see in St George's a location that echoes the splendour and romance of a musician in her prime. •◆*Nicola Balkind*

Photo © Paul Cartwright

Directed by Anand Tucker
Scene description: Hilary plays cello to an adoring German audience
Timecode for scene: 1:01:43 – 1:03:26

DOCKERS (1999)

Torside Timber Berth, Liverpool docks

FIRST BROADCAST on Channel 4 in 1999, *Dockers* recreated the 29-month-long Liverpool Dockers Strike that concluded unsuccessfully just a year before the film was made. After downing tools in support of 80 dockers sacked by Torside in a dispute regarding overtime and rates of pay, all 329 workers employed by the Mersey Docks and Harbour Company were controversially dismissed. Seen through the prism of the emotional and working relationships between veteran docker Tommy (Ken Stott), his son Andy (Lee Ross) and Tommy's 'scab' friend Macca Macauley (Ricky Tomlinson), the film was a painful reminder of the devastation that the dispute wrought on the lives of those on and behind the picket line. The industry synonymous with the city's history was thrust into the national and international spotlight as families were torn apart and friendships ruined during the protracted, bitter dispute. Despite a high profile grassroots campaign, and the support of dockers from around the world, the sacked men were abandoned by their union and successive governments and were eventually forced to accept a settlement. In one early scene, shot on location at the Torside Timber Berth, now incorporated with the Royal Seaforth Container Terminal, Andy and his fellow workers legally refuse to work unpaid overtime, knowing that the request breaks the terms of their working conditions. 'If you walk off this ship you're finished', the gang is told by their foreman. When they do just that they are instantly sacked by the company's managing director. It was the beginning of an ignominious chapter in the city's often turbulent fortunes. •◦**Neil Mitchell**

Photo © Carl Davies

Directed by Bill Anderson
Scene description: 'We're working to a finish'
Timecode for scene: 0:12:56 – 0:14:42

GOING OFF BIG TIME (2000)

LOCATION *Everton Brow*

HIRED BY KINGPIN ARTHUR MCCANN (Stan Boardman) to shift a consignment of pills, small-time crook Mark Clayton (Neil Fitzmaurice) acquires an ice-cream van and parks on Everton Brow to flog the merchandise inside soft-freeze cones. Ignoring Norman (Anthony Audenshaw) and three other plain-clothes policemen in a car nearby, Clayton soon has a queue of eager customers for his 'crazy cones' and it's only a matter of time before Norman sidles over. Instead of being suspicious, however, the cocky copper is on the scrounge and uses his badge to coerce Clayton into handing over four complimentary oyster shells. As he prepares the wafers, Clayton crushes a handful of pills and sprinkles them on the ice-cream, along with some hundreds and thousands, chopped nuts, lashings of raspberry sauce and a chocolate flake. By the time the bizzies start tripping, however, Clayton and his crew are back in the pub toasting their entry into the underworld. The gang would later employ equally larky tactics on a building site to launch its protection scam and this blend of crime and comedy prompted some to draw comparisons with Quentin Tarantino. Such praise was over-effusive, as this scene owes more to Bleasdale and *Brookside* than *Pulp Fiction* (1994). Yet, the view towards Liverpool's iconic cathedrals and St John's Beacon suggests a city in thrall to the actual pushers, pimps and protection racketeers who were infinitely more terrifying than the caricatures who became the staple of the BritCrime boom initiated by Guy Ritchie's Mockney saga, *Lock, Stock and Two Smoking Barrels* (1998). ➻**David Parkinson**

Photo © Paul Cartwright

Directed by Jim Doyle
Scene description: Gangsters sell drugs from an ice-cream van despite police surveillance
Timecode for scene: 0:40:24 – 0:47:14

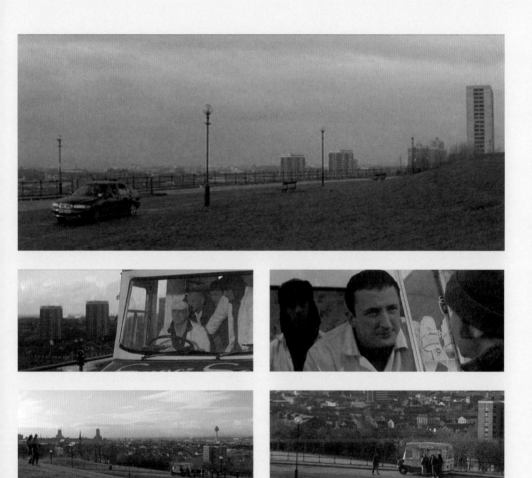

THE 51ST STATE (AKA FORMULA 51) (2001)

LOCATION *Anfield, Anfield Road*

THERE'S NO FIERCER RIVALRY in English football than that between Liverpool and Manchester United. Anfield is the perfect, tension-suffused setting for the denouement of this abrasively playful thriller. Since absconding from Los Angeles convinced that he has offed drug baron The Lizard (Meat Loaf) in a laboratory explosion, kilt-wearing pharmacologist Elmo McElroy (Samuel L. Jackson) has been touting a new wonder drug around Liverpool with the assistance of Felix DeSouza (Robert Carlyle), a fixer whose ex-girlfriend, Dawn 'Dakota' Parker (Emily Mortimer), just happens to be an assassin stalking McElroy in order to pay off her gambling debt to The Lizard. After abortive encounters with mobster Leopold Durant (Ricky Tomlinson) and skinheaded chancer Blowfish (Stephen Walters), Elmo finally agrees to do business with crook of all trades Iki (Rhys Ifans), whose private box at Anfield affords Elmo the `total privacy in a very public place' he craves. Obviously, nothing can run that smoothly and Dawn and The Lizard burst in shortly after kick-off. However, no sooner has the latter dispatched Iki than he discovers that POS 51 is not a sublimely potent legal high but a placebo. Moreover, he learns the cocktail he has just downed has been doctored and the subsequent chemical reaction causes him to detonate, splattering the window with gore just as the Mighty Reds score at the Kop end. The entire scene is risibly implausible, but Carlyle revels in the opportunity to play another Scouser after his murderous Hillsborough survivor in the `To Be a Somebody' episode of *Cracker* (1994). **↦David Parkinson**

Photo © Paul Cartwright

Directed by Ronny Yu
Scene description: Drug dealer The Lizard explodes in an Anfield hospitality box
Timecode for scene: 1:14:12 – 1:22:02

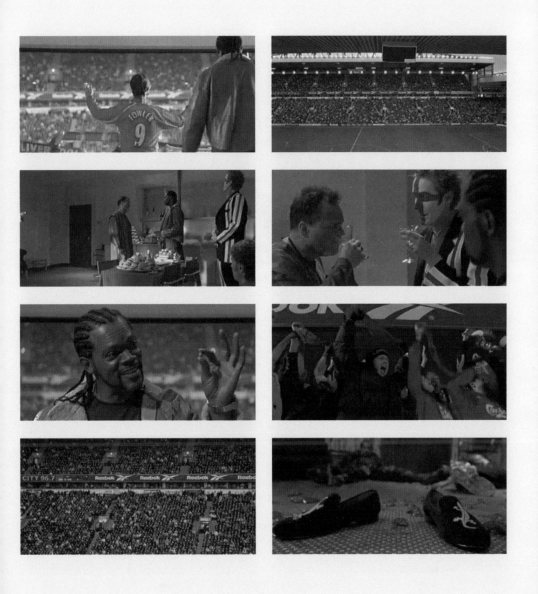

THE VIRGIN OF LIVERPOOL (2003)

LOCATION *The Embassy Bingo Hall, Borough Road, Wallasey*

FROM THE FLICKERING ILLUMINATION of the fruit machines, to the lacklustre patterned carpets, buildings from the turn of the twentieth century designed for commercial entertainment share identikit dusty red curtains, a sorry history of neglect, and plastic beaded decor that no longer shimmers as it once did. The Embassy Bingo Hall in Wallasey, originally opened in December 1899 as The Irving Theatre by Sir Henry Irving, is no exception to this rule. In *The Virgin of Liverpool* Sylvia Conlon (Imelda Staunton) is given a job at her local bingo club (The Embassy) singing golden oldies for a crowd that is mostly comprised of crabby, middle-aged housewives. Since her husband Frank (Ricky Tomlinson) lost his job as a bus driver she's become the only breadwinner in the household and like many a downtrodden spouse, gets little thanks for it. Watching Staunton in her pink dress and gold hoop earrings, belting out Tom Jones's 'Delilah', one can't help but notice how profoundly connected the character of Sylvia is with this distinctly discoloured old hall. Just as this edifice went from being a theatre, to a cinema to a bingo club, Sylvia has gone from lover, to mother, to someone who is now barely acknowledged. 'It's like Frank stopped actually seeing me years ago,' she at one point confesses to their local priest. Like The Embassy, nobody marvels at Sylvia's beauty as they did in her youth; her glamour is faded, forgotten, and no quantity of lavish make-up can cover over the cracks.
➝ Helen Cox

Photo © Paul Cartwright

Directed by Lee Donaldson
Scene description: Sylvia belts out 'Delilah'
Timecode for scene: 0:38:51 – 0:39:58

THIS LAND'S THE PLACE I LOVE AND HERE I'LL STAY

Merseybeat on Film

Text by
NICK
RIDDLE

SPOTLIGHT

IT'S A KEY early scene in Beatles mythology: a few brief minutes of rough black-and-white footage of the band performing 'Some Other Guy' at the Cavern, shortly after Ringo had joined, captured on 22 August 1962 by a Granada Television film crew sent to the club to film up-and-coming bands for the programme Know The North. Filmed records of the Beatles playing live in their home city at any point during their career are few and far between – in fact, that Cavern gig caught on camera is virtually the last time the Fab Four appear on film in Liverpool outside of the newsreels that reported their public appearances in the place of their birth once Beatlemania had broken out. If you go looking for Liverpool in their feature-length and promotional films you won't catch many glimpses; there it is briefly in the early scenes of *Yellow Submarine* (George Dunning, 1968), albeit as static photographic backdrops to the cell animation, and there it is again as a handful of fleeting street scenes during

the promo for 'Penny Lane', although these were intercut with shots of John, Paul, George and Ringo that were actually filmed on the streets of London and Sevenoaks.

The Lime Street Station shots that can be seen at the beginning of *A Hard Day's Night* (Richard Lester, 1964) were actually filmed at London Marylebone. It was a mark of the band's success that they moved to the capital, hence the London setting of *A Hard Day's Night*, a film that Andrew Sarris described, somewhat over-elaborately, in the Village Voice as

the *Citizen Kane* of jukebox musicals, a brilliant crystallization of such diverse cultural particles as the pop movie, rock 'n' roll, cinema verite, the nouvelle vague, free cinema, the affectedly hand-held camera, frenzied cutting, the cult of the sexless subadolescent, the semidocumentary and studied spontaneity.

What is successfully captured in *A Hard Day's Night* is the sense that wherever the Beatles are is Liverpool, as though they exist within a bubble of Scouse-made oxygen that sustains them, and in travelling south they are laying a pipeline for the rarefied and infectious Mersey air to flow through and bring colour to the cheeks of the capital's population. Of course the 'Mersey Sound' was actually made by the bands who rode in their wake; it was left to Brian Epstein's second signing, Gerry and the Pacemakers, to embody the more down-to-earth Liverpool. This they did, in the only Merseybeat movie actually filmed in Liverpool: *Ferry Cross the Mersey* (1965).

Prior to this, the first movie to attempt to exploit the city's pop stars was *These Dangerous Years* aka *Dangerous Youth*, a 1957 vehicle for crooner

Ferry Cross the Mersey includes a montage of documentary-style scenes of kids playing in derelict houses, while Gerry Marsden's voice-over talks about rough, hardscrabble childhoods and having to 'make our own entertainment'; far from breeding psychopaths, this version of Liverpool-streets-as-nursery produces cheeky but goodhearted Scousers for whom popular music is an expression of their love of life rather than an incitement to violent crime. The streets and warehouses of Liverpool, which were sinister settings for dark deeds in the earlier films, are now playgrounds for the larky but unthreatening teenagers in Ferry, and the river Mersey, described sombrely at the beginning of *These Dangerous Years* as a 'desolate backwater [...] a world of crumbling hulks, of forgotten caves [...] where the shining waters breed the germs of crime', is now a beloved waterway to be celebrated in song. *Ferry Cross the Mersey* creates a fictional back-story for the Pacemakers and sets it in a mythical Liverpool, where aspiring popsters ride scooters and go to art school (in reality, Marsden worked on the railways) and where every setting – classroom, ferry, Chinese restaurant, warehouse, stately home – is ripe for a musical number. Most of the feature film biopics about the origins of the Beatles – take *Birth of the Beatles* (Richard Marquand, 1979), *Backbeat* (Ian Softley, 1994) and *Nowhere Boy* (Sam Taylor-Wood, 2009) as examples – are, one could argue, just as guilty of mythmaking, but since they fall into the genre of period film, an entirely different aesthetic applies. These later films feature painstaking reconstructions of early 1960s Liverpool, and the music exists on the same level as the set design: it's there to signify 'past-ness'.

Merseybeat was too short-lived to generate much in the way of film product during its initial life cycle, but its iconography can be found all over the movies and TV shows of the period. For international markets, Liverpool tended to serve as a stand-in for the northern UK in general: *The Man from U.N.C.L.E.*'s David McCallum (a decade on from his role as lead delinquent in *Violent Playground*) was known in the States as 'the blond Beatle' despite being a Scot, and the Monkees traded on the near-as-dammit credentials of their singer, the Mancunian Davy Jones. And just why Walt Disney's *The Jungle Book* (1967) featured a quartet of mop-topped vultures speaking in approximations of a Liverpool accent may never be known, but it speaks volumes about the sheer reach of the city's most famous export. ✠

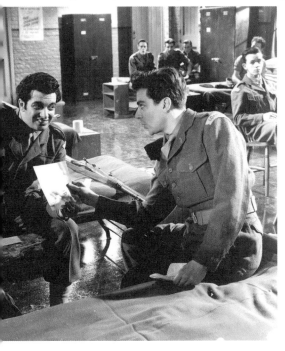

Frankie Vaughan directed by the veteran Herbert Wilcox and produced by Anna Neagle. But you'd be hard-pressed to call it a musical: Vaughan, playing a 'youth' from the Dingle (he was pushing 30 at the time) wrongly accused of murder, only gets to sing a couple of numbers. The following year, Basil Dearden's *Violent Playground*, a *Blackboard Jungle*-style drama of juvenile delinquency, suggested that the youth of Liverpool (the working-class Irish youth at any rate) were having their minds warped by the sinister influence of rock 'n' roll. The 'dangerous years' referred to in Wilcox's film – explained by one character as the period between leaving school and joining the army – became a happy-go-lucky idyll in the beat movies of the mid-1960s, which were meant to be entertainment for the imperilled youngsters themselves.

Merseybeat was too short-lived to generate much in the way of film product during its initial life cycle, but its iconography can be found all over the movies and TV shows of the period.

LIVERPOOL

maps are only to be taken as approximates

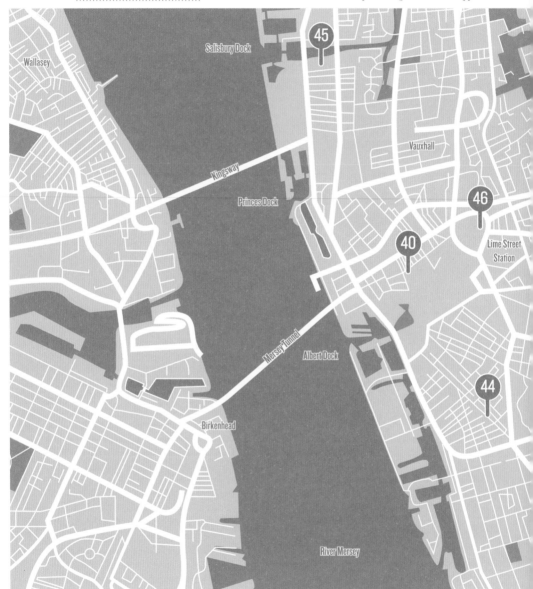

LIVERPOOL LOCATIONS
SCENES 40-46

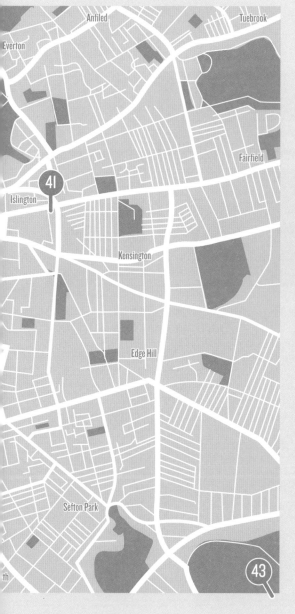

ACROSS THE UNIVERSE (2007)

LOCATION *The Cavern Club, Mathew Street*

AGAINST THE BACKDROP of 1960s cultural, social and political revolution, *Across the Universe* is about parallel yet contrasting lives and Anglo-American juxtapositions. Dualisms are brought together through narrative and audio-visual suturing; a romance between Jude (Jim Sturgess), a working-class artist from Liverpool, and Lucy (Evan Rachel Wood), an all-American girl from a wealthy family, and more than 33 Beatles songs, sung and/or referenced throughout the film. Take the opening sequence, split into two alternating scenes, that begins at an American Prom night, where Lucy sings, 'Hold Me Tight' with Daniel (Spencer Liff), who is about to leave to serve in Vietnam. The lights are bright, the dresses immaculate, the choreography clean and the lyrics innocent. Switching over to Liverpool's subterranean Cavern Club, Molly is doing the same with Jude, who is heading to the United States with the Merchant Navy. Dark, hazy and urban, the dancing is dirty and the same lyrics take on a more sexualized tone. Two different locations, cultures and life-lines, conjoined in the same temporal and narrative site through one single Beatles song. Whilst brief, the Cavern's appearance is symbolic. The club where the Beatles were first spotted by musical entrepreneur-manager Brian Epstein was a momentous place that turned music industry heads north away from London. The Cavern thus represents what lies at the heart of the film: a transformational 1960s youth sub-culture; new beginnings of life, friends, relationships; a new cross-cultural, -social and -political era; and that which encompassed all – across the universe – the music and philosophy of the Beatles. ◆*Esperanza Miyake*

Photos © Paul Cartwright

Directed by Julie Taymor
Scene description: Jude dances with Molly before his departure to America
Timecode for scene: 0:02:40 – 0:04:27

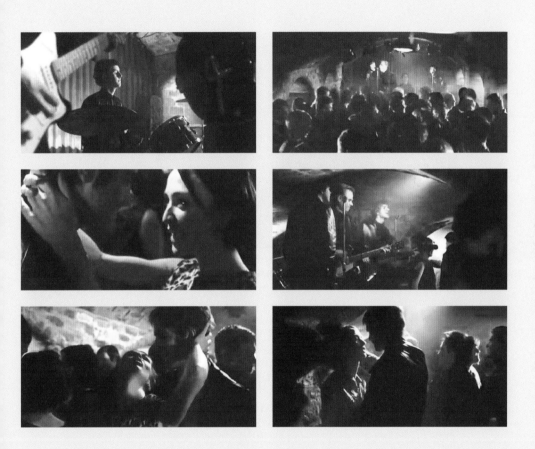

OF TIME AND THE CITY (2008)

LOCATION *Sacred Heart Roman Catholic Church, Hall Lane*

TERENCE DAVIES' FEATURE DOCUMENTARY *Of Time and the City* is a deeply personal cinematic homage to Liverpool, his city of birth. In a series of astute observations, the majority of the film consists of archival footage over which Davies passionately meditates on the grandeur and decline of the city in the post-war years. As much as Davies has a profound personal connection with Liverpool, it quickly becomes apparent that he is also scarred by his upbringing. In one of the film's few modern day shots – yet still deceptively shot in black and white – Davies revisits the parish church of his childhood, the Sacred Heart Roman Catholic Church on Hall Lane. As the camera slowly pans parallel to the pews, Davies recalls: 'Here I wept, wept and prayed until my knees bled ... but no succour came, no peace granted'. In reference to his pleas for forgiveness in front of God, the camera zooms in on a representation of Jesus Christ on display inside the church. Davies adds: 'You who damn but give no comfort. Why do I plead? Why do you not respond?' This key scene, which effectively questions, dismantles, even ridicules the iconography of the church, must be analysed in conjunction with the footage that immediately precedes it; going to watch the wrestling at Liverpool Stadium as an adolescent, Davies alludes to his homoerotic desires by watching the match 'not for its pantomimic villainy, but for something more illicit'. The scene effectively reveals the fact that Davies could not reconcile his Catholic upbringing with his sexuality. ↬*Marco Bohr*

Photo © Paddy Greengrass

Directed by Terence Davies
Scene description: The interior of the film-maker's childhood church
Timecode for scene: 0:13:04 – 0:14:05

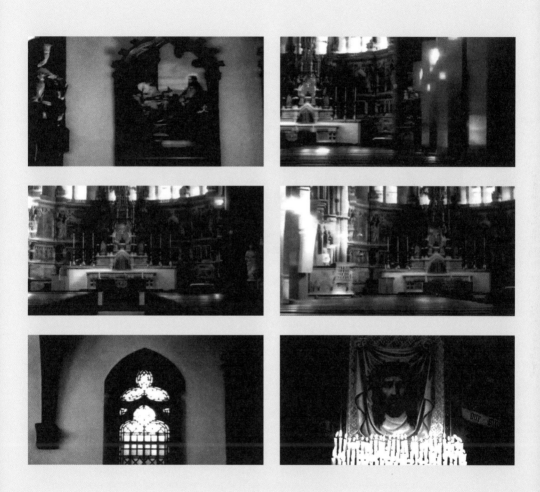

AWAYDAYS (2009)

LOCATION *Bury Bolton Street Train Station, Greater Manchester*

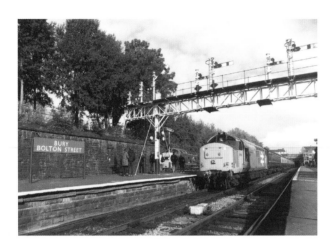

THE SIGHTS AND SOUNDS of late 1970s England are evoked in Pat Holden's
adaptation of Kevin Sampson's visceral 1998 novel, *Awaydays*; a tale of
belonging, friendship, familial angst and subcultures largely set in The Wirral.
Blessed with a memorable soundtrack, *Awaydays*'s narrative, centring around
Carty (Nicky Bell) and his involvement with football hooligan gang The Pack,
sees the pressures of economic deprivation, urban alienation and frustrated
aspirations released through match day violence and nocturnal hedonism.
Carty's turbulent emotional journey from youthful innocence to adult
experience is visually symbolized throughout *Awaydays* by the recurring use
of trains, the mode of transport, along with the coach, used by the hooligans
that stained the country's reputation. The tensions in the friendship between
the enigmatic but disturbed Elvis (Liam Boyle) and Carty come to a tragic head
at the film's conclusion in a sequence that also epitomizes *Awaydays*'s pointed
every-town milieu. As Carty heads off on the train for 'one last awayday',
Elvis sits on the station bridge watching. The journey for both of them comes
to an end in different ways: Elvis's by leaping to his death and Carty's by his
vicious ex-communication from The Pack. Though supposed to be Birkenhead
North, the station seen is Bury Bolton Street, now the headquarters of the
East Lancashire Railway heritage line. Open at weekends and running
themed events and galas, the heritage line and Bury Bolton Street in Greater
Manchester provided the production team behind *Awaydays* with the location,
the trains and the period feel that the film required. •→**Neil Mitchell**

Photo © Paul Cartwright

Directed by Pat Holden
Scene description: One last awayday ...
Timecode for scene: 1:31:30 – 1:33:17

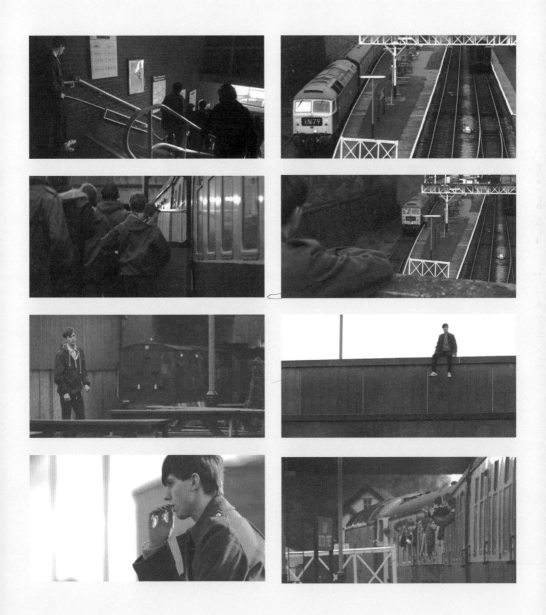

Images © 2009 Red Union Films

NOWHERE BOY (2009)

Woolton Picture House, Mason Street, Woolton Village

A BRITISH BIOPIC about the adolescence life of John Lennon (Aaron Johnson), *Nowhere Boy* delves into the relationships Lennon had with his guardian and aunt, Mimi (Kristen Scott Thomas) and his estranged mother, Julia (Anne-Marie Duff). After a turbulent start to his life, he was brought up with his aunt Mimi at Mendips, Woolton. As a teenager, Lennon became reunited with his mother and together they took day trips in and around the city. One of these trips was to Woolton Picture House, to watch an Elvis Presley film. This is a pinnacle moment in Lennon's life; it is his first exposure to Elvis, and the mania that surrounded Presley and his music. Beatlemania would soon be something Lennon was totally engulfed by, and this scene is an unknown glimpse for him of what is in store. Opening in 1927, Woolton Picture House is the only remaining independent single-screen cinema in Liverpool, and one of only a few in the country. A fire in 1958 drastically altered the cinema, but after repairs and a further refurbishment in 1980, it still retains its traditional art-deco style. There are many myths surrounding Lennon's relationship with the Picture House, with some claiming he and his Quarrymen band-members nicknamed it 'The Bug' and that the cinema inspired some of the lyrics to the Beatles track, 'A Day in the Life'. Although these may be disputed, there is no doubt of the love Lennon had for the cinema, even if he was thrown out on occasions for causing a disturbance! ↦*Rebekka O'Grady*

Photo © Paul Cartwright

Directed by Sam Taylor-Wood
Scene description: John Lennon and his mother watch Elvis at the Woolton Picture House
Timecode for scene: 0:18:08 – 0:19:02

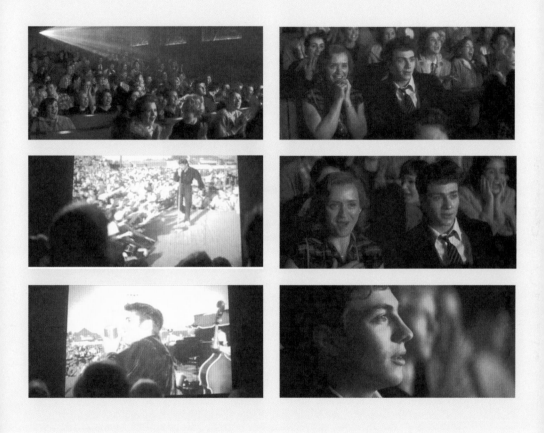

ROUTE IRISH (2010)

LOCATION *St Vincent de Paul Church, St James Street*

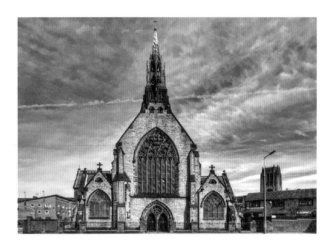

ROUTE IRISH REFERS TO the stretch of road between Baghdad Airport and the Green Zone where US military, government personnel and foreign contractors could live in relative safety at the height of the conflict. Prominent among the foreign contractors were the private military organizations which thrived during the period of the occupation of Iraq. Route Irish was considered the most dangerous stretch of road in the world and the film centres on Fergus, a mercenary who digs into the death of his childhood friend and fellow soldier-of-fortune Frankie who was killed on Route Irish while on duty. Given the danger of the road, few questions were initially asked about Frankie's death and Fergus's investigations uncover some shocking truths about the privatization of war. The altar at St Vincent de Paul Church is ornate and impressive. It is the setting of a eulogy for Frankie delivered by an executive of the private military contractor that he worked for and which Fergus recruited him to. Fergus had secreted himself in the church as it closed the previous night in order to view Frankie's body in its casket, which was closed due to his horrific injuries. In itself an act of desecration but one done out of Fergus's love for Frankie and guilt over his death, as well as genuine grief. The smooth and glib eulogy, however, feels like a real act of blasphemy in such a setting. One does not have to be religious to feel the evident transgression. **◆David Bates**

Photo © Les Auld

Directed by Ken Loach
Scene description: A eulogy delivered for the death of a mercenary
Timecode for scene: 0:06:13 – 0:07:51

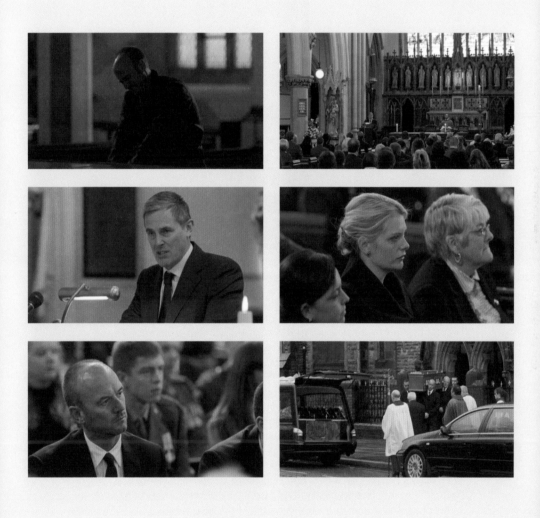

CAPTAIN AMERICA: THE FIRST AVENGER (2011)

LOCATION *Regent Road/Stanley Dock*

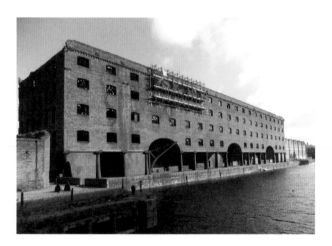

BASED ON THE MARVEL Comics superhero, Johnston's film about sickly yet good-hearted Steve Rogers (Chris Evans) who becomes the protector of America and humanity during World War II, was among a number of big-budget productions to make use of Liverpool locales in recent years. Helped by Dr Abraham Erskine (Stanley Tucci), whose secret formula transforms him into Captain America, Rogers is able to cripple the plans of Nazi megalomaniac Johann Schmidt (Hugo Weaving). Straight after Rogers's successful metamorphosis, Schmidt's assassin Heinz Kruger (Richard Armitage) kills Erskine. Rogers pursues Kruger through Brooklyn's docklands, using a torn cab-door as a shield – his future iconic weapon – in front of a large building. Shot at Liverpool's Stanley Dock, the choice of location may seem ironic for a Hollywood blockbuster with such a patriotic theme. But is it? The large building is Stanley Dock Tobacco Warehouse, constructed in 1900 and still the largest brick structure and warehouse in the world: its longevity, status and scale befit a superhero shielding the world from evil forces. The whole dockland area connected Liverpool to a global network of major port cities between 1850 and 1950 through trade, industry and mobility: a threat and disruption staged in such a pivotal location is apt when we think of Schmidt's world map, a network of pins in cities he plans to destroy. Kruger even attempts an escape aboard a submarine, echoing real history when the docks were raided by the same during the war. An important local-global site, Stanley Dock is thus a perfect location for one superhero's fight against world destruction. •◦*Esperanza Miyake*

Photo © Paul Cartwright

Directed by Joe Johnston
Scene description: Newly transformed Steve Rogers chases Schmidt's assassin, Heinz Kruger
Timecode for scene: 0:40:00 – 0:41:20

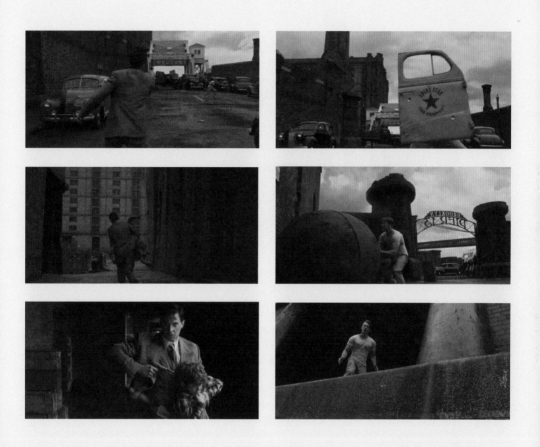

KELLY + VICTOR (2012)

LOCATION *Walker Art Gallery*

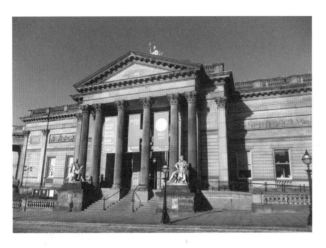

ALTHOUGH THEY HAD ENGAGED in an energetic bout of S&M after meeting in a club, it's their first proper date that proves crucial to understanding the relationship between twentysomethings Kelly (Antonia Campbell-Hughes) and Victor (Julian Morris) in this unflinching adaptation of Niall Griffiths's bestselling novel. Having met by the Shaftesbury Memorial in Sefton Park, they watch some fishermen beside the lake and Kelly reveals she had often come here as a girl with her late father. However, Victor fails to notice the faraway expression and slight shudder as she thinks back and is no more intuitive when they catch the bus into the city centre to visit the Walker Art Gallery. Kelly is struck by a monument depicting Wigan doctor Edward Macloghlin and his wife Eliza, which she had commissioned following his early death at the age of 47 in 1904 from Alfred Gilbert, who sculpted the Eros statues in both Piccadilly Circus and Sefton Park. Kelly is touched by the couple's closeness, but her cynicism returns on seeing Giovanni Segantini's 1891 canvas *The Punishment of Lust* and, once again, Victor misses her meaning when she says that her own mother (Gabrielle Reidy) could be one of the two women suffering in Purgatory for the neglect of their children. Recalling the use of allegorical statues to predicate key plot points in Pip Broughton's *Blood on the Dole* (1994), these exchanges in such civilized surroundings go a long way to explaining Kelly's predilection for bondage and asphyxiation and Victor's powerlessness to prevent his own fate. ✦*David Parkinson*

Photo © Paul Cartwright

Directed by Kieran Evans
Scene description: A tormented woman recognizes facets of her own life in art gallery exhibits
Timecode for scene: 0:35:00 – 0:38:22

Images © 2012 Hot Property Films, Venom Films

GO FURTHER

Recommended reading, useful websites and film availability

BOOKS & JOURNALS

The Beatles on Film: Analysis of Movies, Documentaries, Spoofs and Cartoons
by Roland Reiter
(Transcript Verlag, 2008)

The City and the Moving Image: Urban Projections
Ed. by Richard Koeck and Les Roberts
(Palgrave Macmillan, 2010)

Film, Mobility and Urban Space: A Cinematic Geography of Liverpool
by Les Roberts
(Liverpool University Press, 2012)

'Liverpool in film: J.A.L. Promio's cinematic urban space'
by Richard Koeck
Early Popular Visual Culture (7: 1, 2009)
pp. 63–81

'Mapping, memory and the city: Archives, databases and film historiography'
by Julia Hallam and Les Roberts
European Journal of Cultural Studies
(14: 3, 2011)
pp. 355–72.

Terence Davies (British Film Makers)
by Wendy Everett
(Manchester University Press, 2004)

X-Films: True Confessions of a Radical Filmmaker
by Alex Cox
(I.B. Tauris & Co Ltd, 2008)

ONLINE

BFI Screenonline Liverpool: A City on Screen
http://www.screenonline.org.uk/liverpool/

FACT (Foundation for Art and Creative Technology)
http://www.fact.co.uk/

Liverpool Film Office
http://www.liverpool.gov.uk/Business/film-office/

Liverpool Lift-Off Film Festival
http://www.liverpoollift-off.com/

Liverpool Screen School
http://www.ljmu.ac.uk/LSS/

Mapping the City in Film: A Geohistorical Analysis
http://www.liv.ac.uk/lsa/cityinfilm/

North West Film Archive
http://www.nwfa.mmu.ac.uk/

Edge Hill University Department of Media
http://www.edgehill.ac.uk/media/

Liverpool Hope University Department of Politics, History, Media and Communication
http://www.hope.ac.uk/artsandhumanities/historyandpolitics/

University of Liverpool Department of Communication and Media
http://www.liv.ac.uk/communication-and-media/

CONTRIBUTORS

Editor and contributing writer biographies

EDITORS

JEZ CONOLLY holds an MA in Film Studies and European Cinema from the University of the West of England, is a regular contributor to *The Big Picture* magazine and website and has co-edited the *World Film Locations* books covering Dublin and Reykjavík. His book *Beached Margin: The role and representation of the seaside resort in British films* was published in 2008. He is currently working on a monograph about John Carpenter's *The Thing*. In his spare time he is the Arts and Social Sciences & Law Faculty Librarian at the University of Bristol.

CAROLINE WHELAN is a freelance writer and researcher. A big fan of films, she has co-edited (with Jez Conolly) the Dublin and Reykjavík volumes in the *World Film Locations* series.

CONTRIBUTORS

NICOLA BALKIND is a writer and digital freelancer based in Glasgow. She contributes to a number of volumes in the *World Film Locations* series as well as BBC Radio Scotland's *Movie Café* and regional press. You can find Nicola online at *http://nicolabalkind.com* and on Twitter *@robotnic*.

DAVID OWAIN BATES spent his childhood on a Carmarthenshire farm, has looked after children with learning disabilities in Bristol, worked as a chef in a Chinese restaurant in West Wales, and run a pub in South London. He worked in an Internet company at the height of the dot-com boom, where he drank a lot of the venture-capitalist's money in the finest bars in Soho and lost his job in the crash. He has been involved in an international charity start-up and solved more computer problems and server crashes than he can recall. One day he will decide what he wants to do when he grows up but until then is dealing with an addiction to DVD box-sets and a love of the liminal dream world of the cinema, where he mutters darkly about safety lights ruining the magic. He wants to live in the Everyman in Hampstead.

MARCELLINE BLOCK (BA, Harvard; MA, PhD candidate, Princeton) taught in various disciplines at Princeton, including as a lecturer in history. Publications include *World Film Locations: Paris, Las Vegas* and *Marseilles*, as well as *Situating the Feminist Gaze and Spectatorship in Postwar Cinema*, which was named Book of the Month (Cambridge Scholars Publishing, January 2012) and was translated into Italian. She is co-editor of *Unequal before Death, Gender Scripts in Medicine and Narrative* and *Critical Matrix: The Princeton Journal of Women, Gender, and Culture* (volume 18). Her articles and book chapters about film, literature and visual art appear in Chinese, English, French and Russian. She frequently lectures, including about Paris in Film at 92Y TriBeCa, New York City.

MARCO BOHR is a lecturer in Visual Communication at Loughborough University. His blog on visual culture can be found at *www.visualcultureblog.com*.

PAUL CARTWRIGHT is a keen walker and photographer who lives in Birkenhead, Merseyside.

HELEN COX is Editor in Chief of *New Empress* Magazine and author of the upcoming book: *True Love is Like the Loch Ness Monster and Other Lessons I Learnt From Film*. After qualifying for her MA in creative writing in 2006 she came to London to start a career in film journalism. She has since contributed regular reviews and features to the likes of Guardian Film, *Den of Geek, Lost in the Multiplex, Flick Feast* and *Geek Planet Online*.

DR WENDY EVERETT is Reader in French and Film at the University of Bath. She is a graduate of the University of Wales, and carried out postgraduate research in London, and Paris, where she also lectured and worked as a freelance translator. Her principal research interests are in European cinema, and recent publications in this field include *Revisiting Space* (Peter Lang, 2005), *European Identity in Cinema* (Intellect, 2005), *Terence Davies* (Manchester University Press, 2004), *Cultures of Exile* (Berghahn, 2004) and *The Seeing Century: Film, Vision, and Identity* (Rodopi, 2000), as well as numerous journal articles and book chapters. She regularly lectures and gives papers in Europe and the United States. Current undergraduate teaching includes contemporary French and European literature, film and art; postgraduate teaching centres on the MA in European Cinema Studies. She supervises a number of PhD film students.

DR JULIA HALLAM, Reader in Film and Media, University of Liverpool, has led two AHRC funded projects exploring the relationship between film and urban space. The 'City in Film' project collated and created an online searchable database of films made in and about the city as part of a wider investigation into the ways in which the city had been represented in moving image culture since the first images of the city were taken in 1897. Her most recent ➜

CONTRIBUTORS

Editor and contributing writer biographies (continued)

project, *Mapping the City in Film: A geo-historical analysis*, has developed new methodologies for multi-disciplinary and intermedial analysis of moving image texts using Geographical Information Systems (GIS) software and helped to create an interactive map of Liverpool with the Museum of Liverpool. An edited collection *Locating the Moving Image: New Approaches to Film and Place* is due to be published by Indiana University Press in 2013.

SCOTT JORDAN HARRIS is a British film critic and sportswriter. Formerly Online Arts Editor of *The Spectator* and Editor of *The Big Picture* magazine, he is now a culture blogger for the *Daily Telegraph*; a contributor to BBC Radio 4's *The Film Programme*; and Roger Ebert's UK correspondent. His work has been published by, among many others, *Sight & Sound*, *The Spectator*, *The Guardian*, BBC online, the *Chicago Sun-Times*, the *Huffington Post*, *Fangoria*, *movieScope*, Turner Classic Movies, Film4.com and The Australian Film Institute. Scott has contributed to more than a dozen books on film and is also editor of the *World Film Locations* volumes on New York, New Orleans, Chicago and San Francisco. In 2010 his blog, *A Petrified Fountain*, was named by *Running in Heels* as one of the world's 'best movie blogs'. He is on Twitter @ ScottFilmCritic.

SUSAN JAMES is a war studies graduate who gave up a promising career as a barbarian so that she could write more. Reality has however, forced her to (temporarily) slum it in retail hell; working in the plethora of opportunity that is the DVD rental industry. When not weeping into pyramid displays of popcorn, she can be found lecturing impressionable young women on the evils of Bella Swan. Failing that, she'll be in the middle booth of her local pub with a pint and a pen. She hopes that this writing malarkey will one day take off and allow her to get a more grown-up writing space, because her Grandmother would really like her dining room table back.

LINDA JONES has just finished an honours degree in History of Art and Museum Studies at Liverpool John Moores University. She has always been interested in art and writing having written a play called 'The Original Emily' and contributed to the 'Liverpool Doors' exhibition at the new 'Museum of Liverpool' showcasing the poetry of Roger McGough which opened in March 2011. Presently she is supporting a student who is working towards gaining a degree in computing at John Moores University. She works creatively across various mediums and hopes to exhibit her work soon.

TIM KELLY is an entertainment journalist and film critic currently calling Minneapolis, Minnesota his home. An editor of the highly respected *CHUD.com* (Cinematic Happenings Under Development), he's had the opportunity to rub elbows with some of the best and brightest working in the film-making industry today. Tim studied at St John's University in the arenas of communication, film study and writing and credits his family for tolerating and supporting an all-encompassing movie-watching habit throughout his youth. He is a firm believer in the transformative power of film; a trait that often shines through in his affectionately honest yet humorous reviews.

JOHN MAGUIRE stems from Belle Vale, Liverpool. He studied drama at the University of Wales and has lived all over the United Kingdom before moving back to Liverpool. Since returning he has directed a number of productions in Liverpool's fringe venues. Notably, John has staged and directed three of his own plays, *Heart* (2010), *Bruise* (2012) and recently *Weave ... the story of a Scouse Girl with a possessed hair extension* (2012) which premiered at the Lantern Theatre, Liverpool as part of the Shiny New Fringe Festival and due to its sell-out success is scheduled to go to Edinburgh in 2013. John's first children's book, *Sophie and The Spider*, a collection of poems for five to seven year olds was published in August 2012.

DR JACQUI MILLER is Senior Lecturer in Visual Communication at Liverpool Hope University teaching a range of film studies courses with a particular emphasis on the relationship between film and history. Her recent publications include *The French New Wave and the New Hollywood: Le Samourai and its American Legacy* and *An American in Europe: US Colonialism in* The Talented Mr Ripley *and* Ripley's Game. She leads the Liverpool Hope Popular Culture Research Group and hosts the annual international conference *Theorising the Popular* which sets out to challenge the hierarchies within 'popular' and 'high' culture.

NEIL MITCHELL is a writer and editor based in Brighton, East Sussex. He co-edited *Directory of World Cinema: Britain* and edited the London and Melbourne editions of the World Film Locations series. He edits Intellect's *The Big Picture* magazine and is the author of the Carrie edition of Auteur Publishing's Devil's Advocates series.

DR ESPERANZA MIYAKE is an associate tutor at Liverpool John Moores University where she teaches the

BA (Hons) Mass Communications course. Her PhD thesis was on Queer Ethnographies of Music and Sexuality. She has and continues to present, publish and review works on popular music, popular culture and race/raciality, particularly in relation to sexuality. She is the author of the award-winning essay, 'My, is that Cyborg a Little Queer?' (*IJWS*, 2004). She is the co-editor (with Dr Adi Kuntsman) of *Out of Place: Interrogating Silences in Queerness/Raciality* (Raw Nerve, 2008). Esperanza is also a keen motorcyclist and tries to incorporate her passion into her teaching wherever she can. For example, she has led and taught a module on Public Information Campaigns, using the UK's 'Think Bike!' campaign as a focal point.

Dr Díóg O'Connell lectures in film and media at the Institute of Art Design and Technology in Dun Laoghaire, Co. Dublin. Her book *New Irish Storytellers: Narrative Strategies in Film* was published by Intellect Press in 2010 and she is co-editor of *Documentary in a Changing State* (Cork University Press, 2012). She has written extensively on Irish cinema in books, journals and magazines.

Rebekka O'Grady is currently an undergraduate at Liverpool John Moores University. Planning to graduate in 2013 with a BA in English, Media and Cultural studies, she is an aspiring journalist. Born and currently living in Liverpool, she loves what the city has to offer in terms of its culture and personality. Rebekka regularly contributes articles to her own blog, the university newspaper and Liverpool-based arts magazine *The Double Negative*. Most recently she spent a summer working in Florida and plans more trips abroad to explore what the world has to offer. You can find her at *http://thescousebookworm. wordpress.com.*

David Parkinson is a Liverpudlian film critic and historian. A contributing editor at *Empire* magazine, he also reviews for *Radio Times*, *MovieMail* and the *Oxford Times* and has written regularly for *The Guardian* film website and other internet outlets, among them the 'Festivals & Seasons' page on *Empire Online*. In addition to editing, *Mornings in the Dark: The Graham Greene Film Reader* (1993), he has also written several books, including *The Bloomsbury Good Movie Guide* (1989), *The Young Oxford Book of Cinema* (1996), *History of Film* (1997; 2nd edn, 2012), *Oxford at the Movies* (2004), *The Rough Guide to Film Musicals* (2007) and *100 Ideas That Changed Film* (2012). Most importantly, however, he supports Liverpool Football Club and is a Beatles fanatic.

Nick Riddle has written gags for BBC Radio, reading guides for Random House, ad copy for an online casino, and articles for the Kinsey Institute. He has written on film in the United States and the United Kingdom, and won two awards from the Society of Professional Journalists in the United States for his arts writing. He works as a writer/ editor at the University of Bristol. He also blogs about an obscure troubadour legend at jaufre-outremer.blogspot. co.uk and is working on a novel about a 1960s beat band. In his spare time he introduces his daughters to the finer points of popular culture while fighting a rearguard action against Twilight and Ben Stiller movies.

Dr Les Roberts is the author of *Film, Mobility and Urban Space: A Cinematic Geography of Liverpool* (Liverpool University Press, 2012). From 2006–10 he was lead researcher on the AHRC-funded projects 'City in Film: Liverpool's Urban Landscape and the Moving Image' and *Mapping the City in Film: A Geo-historical Analysis*. His research interests are in the cultural production of space, place and mobility, with a particular focus on film and popular music cultures. He is editor of *Mapping Cultures: Place, Practice, Performance (Palgrave, 2012)*, and co-editor of *Liminal Landscapes: Travel, Experience and Spaces In-between* (Routledge, 2012) and *The City and the Moving Image: Urban Projections* (Palgrave, 2010). For information on recent research activities and publications, see *www.liminoids.com.*

Roger Shannon is Professor of Film and Television in the Department of Media at Edge Hill University, Lancashire. He has been a national Film Fund head at Scottish Screen, 2004–05; UK Film Council, 2000–01; and at the BFI 1997–2000. He was Founding Director of the Moving Image Development Agency in Liverpool from 1992–97, where he established the country's first regional film investment fund. Before that he was Director of the Birmingham International Film/Television Festival, 1985– 92. Roger took an MA in Contemporary Cultural Studies at the University of Birmingham, 1977–79, before setting up the Birmingham Film/Video Workshop in 1979 and leading it into successful production ventures with the BFI and Channel 4. He has been associated, as exec producer or funder, with over twenty award-winning UK feature films, including *Butterfly Kiss*, *Under The Skin*, *Beautiful People*, *Peggy Su!*, *The Lawless Heart*, *I Could Read The Sky*, *Downtime* and *Festival*.

FILMOGRAPHY

All films mentioned or featured in this book